FOCUS ON
light & exposure in digital photography

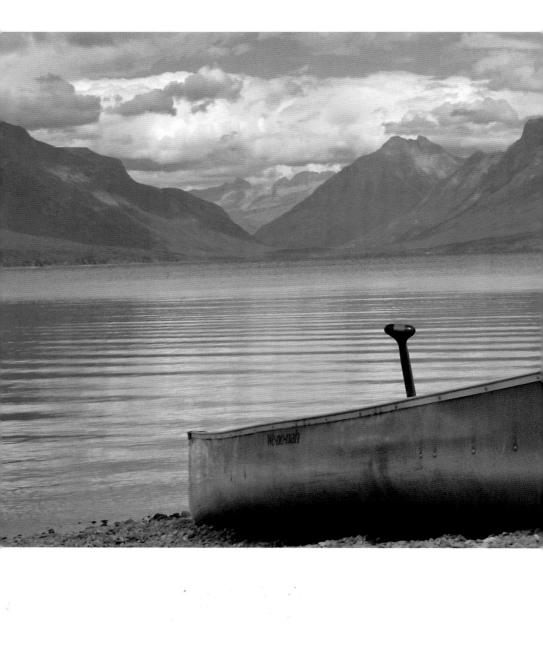

FOCUS ON
light & exposure in digital photography

George Schaub

LARK
PHOTOGRAPHY
BOOKS

A Division Of Sterling Publishing Co., Inc.
New York / London

Art Director: Tom Metcalf
Cover Designer: Thom Gaines
Production Coordinator: Lance Wille
Editor: Kevin Kopp

Library of Congress Cataloging-in-Publication Data

Schaub, George.
 Focus on light & exposure in digital photography / George C. Schaub. – 1st ed.
 p. cm.
 Includes index.
 ISBN 978-1-60059-636-0
 1. Photography–Exposure. 2. Photography–Digital techniques. I. Title.
 TR591.S385 2010
 771–dc22
 2010002578

10 9 8 7 6 5 4 3 2 1
First Edition

Published by Lark Books, A Division of
Sterling Publishing Co., Inc.
387 Park Avenue South, New York, N.Y. 10016

Text © 2010 George Schaub
Photographs © 2010 George Schaub unless otherwise specified.

Distributed in Canada by Sterling Publishing,
c/o Canadian Manda Group, 165 Dufferin Street
Toronto, Ontario, Canada M6K 3H6

Distributed in the United Kingdom by GMC Distribution Services,
Castle Place, 166 High Street, Lewes, East Sussex, England BN7 1XU

Distributed in Australia by Capricorn Link (Australia) Pty Ltd.,
P.O. Box 704, Windsor, NSW 2756 Australia

If you have questions or comments about this book, please contact:
Lark Books
67 Broadway
Asheville, NC 28801
(828) 253-0467

Manufactured in China

ISBN 13: 978-1-60059-636-0
For information about custom editions, special sales, premium and corporate purchases, please contact Sterling Special Sales Department at 800-805-5489 or specialsales@sterlingpub.com. For information about desk and examination copies available to college and university professors, requests must be submitted to academic@larkbooks.com. Our complete policy can be found at www.larkbooks.com.

To Grace, and the light we've shared.

contents ||||||||||||||||||||||||||||

Introduction

This Book and Your Photography

This book is set up as a series of applied techniques that are intended to help you make the best exposures you can. While it takes a close look at digital cameras and their controls, this book is essentially about photography and making great photographs. Its aim is to help you improve your photography, making photos that express what you see and recording precisely what prompted you to snap the shutter in the first place.

Additionally, this book concentrates on using light to make the best pictures possible in the field, even though there are times when you will also use image-processing techniques afterward. But the better you expose and set up the image when you record it, the less work you have to do later when you process it. Following the tips and techniques in this book will help you improve images directly out of the camera.

Seeing light and making exposures that capture your awareness and sense of that light takes practice. Some of this process is instinctive, but technique is learned, and that is where this book comes in.

Each technique covered here will combine visual awareness and photographic tools that come together every time a photograph is made. As you study these exercises, you will find yourself becoming familiar with the process so that seeing and applying technique become one. You will find yourself becoming familiar with the features and functions on your camera that are most useful to produce the photographic results you want.

Each section is organized in the following fashion:

- A visual exercise and/or exposure technique.

- The tools we are going to use: This can include metering modes, menu settings, aperture and shutter speed combinations, exposure compensation settings, etc.

- The technique described in both words and illustrative images.

- The settings used for the image shown.

While the exercises are arranged according to various groups, it is not necessary to read this book sequentially from front to back. It is intended as a field guide to provide inspiration and technical guidance as you shoot.

Some Quick Thoughts Before We Begin

Everyone sees differently, but there are some visual elements and considerations that are fairly common to all photographs. This checklist might be helpful when you start thinking in a systematic way about making photographs. As you gain experience and apply these ideas over time, they will become second nature within your photographic method, and always available to you.

• What image effects will be most effective for the photo?

There are two primary image effects in photography, and both depend on the lens and shutter settings:

1. Showing motion

2. Establishing the relationship of foreground to background through focusing—what's sharp and unsharp in the frame.

While these two effects seem basic, every photograph relies on them to serve as the foundation or context of what is being shown. Using shutter speed and aperture settings in creative ways for each photo puts incredible interpretive power in your hands. We'll explore these tools thoroughly, and you'll see how, for example, using one aperture setting over another on a subject a few feet away, or setting varying shutter speeds when photographing a waterfall, can make a profound difference in your photographs.

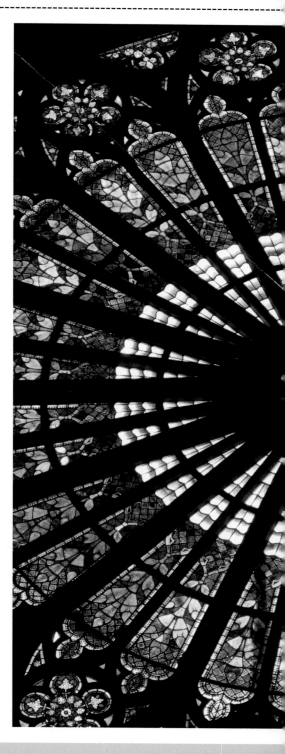

• How do I make a photograph of what I see rather than how the camera records the scene?

A camera is a recording tool and the challenge is to make it work for you rather than rely on its automated, pre-programmed response to light and color. There is usually a difference between what you see (both physically and emotionally) and what the camera might record. The two may accidentally coincide, but that will happen only occasionally unless you know how to use the tools at your disposal to take control of your photographic results. One of the most important realizations about cameras and how you see is that a gap exists between the two. Narrowing that difference through technique can have a profound effect on the type of images you make.

• What is the main subject or statement I am making with this photograph?

Not every photograph has to bear the responsibility of deep "meaning," but there should be some sense of the main subject or idea that urged you to make the photo. The subject could be as simple as the way the light falls, or an aesthetic study of tonality, or it could be a depiction of a landscape or environment, a portrait, or a street scene. Knowing what the subject or idea is will guide you in how you frame, expose, and compose the picture.

Each moment holds the potential for beauty, truth, and communication. Getting great photos that depict these moments is sometimes a matter of having the confidence that you can capture it using your vision and the tools at your disposal.

That's what this book is all about.

Exposure is how the light and dark in an image interplay. It is the balance between bright areas and shadows, and the spaces in between, and how to best record those values, colors, and tones with your camera.

The scene below seems simple enough,
but if you can master this type of lighting
and subject situation, you will have gone a
long way towards understanding exposure.
When you finish this book, come back to this
image and think about the ways you can make
a recording that will give you a textural white,
an open shadow, and a deep black. There are
numerous solutions to this puzzle, all of which
are correct, so do return and fill out the
following blanks:

Metering pattern: _____

Exposure mode: _____

Tools used: _____

Achieving the
Best Exposure

Understanding exposure is vitally important to the process of photography and to making good digital photographs. Exposure is fundamentally about light. The term itself becomes shorthand for the delicate balance between the light sensitivity of the sensor and the amount of existing light in the scene you are recording. You can adjust the sensitivity through the camera's ISO setting to regulate the sensor's electronic signal. Meanwhile, the camera and lens control the existing light in two primary ways: Through the opening in the lens (aperture), and by the length of time the camera's shutter is open (shutter speed).

Proper exposure combines these factors—sensitivity, lens opening, and shutter speed—in various proportions to produce an image that is pleasing to you, the photographer, and hopefully to other viewers as well. The aim is to capture as full a range of brightness and color as possible, without overwhelming the photo with large blank areas of pure white (overexposure) or portions that are black and devoid of detail (underexposure).

I.I The Sensor's Sensitivity to Ligh

How It Affects Exposure

Tools:

- ISO Setting
- Manual Exposure Mode
- Tripod

Exposure is about the quantity of light used to record a photograph. One way to consider a digital camera's exposure system is to imagine a seesaw on which you want to achieve balance between the sensor's sensitivity to light and the brightness values (the light and dark areas) in the scene. The camera allows you to increase or decrease the sensor's sensitivity by changing the ISO number. The camera also allows you to change the amount of light reaching the sensor by adjusting the aperture and shutter speed (see the next chapters for more on these light controlling functions).

Using ISO to Your Advantage

Light sensitivity and quantity become important factors in understanding how to use ISO, because raising the ISO number increases the sensor's sensitivity to the light that falls upon it, while lowering the ISO decreases sensitivity. The level of sensitivity you choose depends on the light available in the scene. In dim light you might need more sensitivity—a higher ISO number—if shooting handheld; while bright light usually requires less sensitivity, or a lower ISO number (given that you do not use flash).

ISO is a standard created by scientists; consequently the degree of sensitivity delivered by any given ISO setting is not an intuitive measurement. ISO 100 is the lowest sensitivity number in most digital camera systems (ISO 200 in some Nikons). The term "ISO 100" means little by itself, but is a key element in determining exposure values when placed in the context of a three-way balancing act, along with aperture and shutter speed settings, for recording the scene's brightness.

ISO therefore poses part of an exposure solution to any given light level. If you need more or less light to affect how the aperture

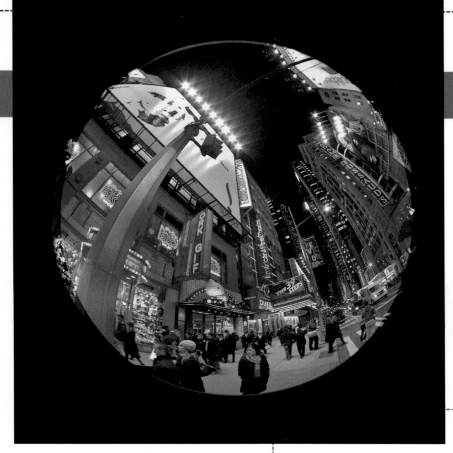

and shutter speed are set, you simply raise or lower the ISO setting in the camera. For example, you usually have to lengthen your shutter speed when the light gets low in order to allow more light into the camera (as in the night shot of New York's theater district above, shot with a fisheye lens). This makes your photo susceptible to blur due to camera movement. Setting a higher ISO will permit you to set a faster shutter speed, reducing the effects of camera movement. You will always want to set a higher ISO for more light sensitivity (when you need a faster shutter speed or narrower aperture), or a lower ISO for less light sensitivity (when you want a wider aperture or slower shutter speed). One of the advantages of digital cameras is that you can change ISO on every frame.

Exposure Mode: *Aperture Priority*
Aperture: *f/16*
Shutter Speed: *1/125 second*
ISO: *100*
Metering: *Spot*
White Balance: *Tungsten*

Many cameras offer an ISO range between 100 and 1600, with some going up to 3200 and beyond. Every time you double the ISO (in effect doubling the sensitivity of the sensor), you are adding one full stop of sensitivity to light. Lowering the ISO by half decreases the sensitivity one full stop. This proportion is reflected in how you can change aperture and shutter speed by full stops in response—halving ISO would allow you to go, for example, from f/8 to f/5.6; and doubling the ISO would allow you to increase shutter speed from, say, 1/60 second to 1/125 second.

In general, you want to use a high ISO setting in low light, and a lower ISO in brighter light. While it may be tempting to use high ISO settings much of the time, assuring enough light sensitivity to avoid underexposure, there is often a price to pay. When all else is equal, the lowest possible ISO leads to the best image quality. That's because increased sensitivity in a digital camera is gained by applying additional electrical charges across the sensor, which result in electronic noise in the image. Noise reduction filters can help this problem, either in-camera or as software in the computer during post-processing, but they do not entirely solve it. Noise has gotten better as camera processing systems improve, but it is still a problem. This photo inside New York's Grand Central Station (right) was shot handheld at a high ISO, and the noise is apparent.

You might think all shots made in low light, especially at night, require a high ISO setting, but that's only if you shoot handheld. Mount the camera on a tripod and you can shoot at lower ISO settings, which generally yield much less digital electronic noise. That's the case with this classic Las Vegas neon cowboy, recorded at ISO 200.

Exposure Mode: *Aperture Priority*

Aperture: *f/5.6*

Shutter Speed: *1/8 second*

ISO: *200*

Metering: *Spot*

White Balance: *Tungsten*

Tripod

Exposure Mode: *Shutter Priority*

Aperture: *f/4*

Shutter Speed: *1/125 second*

ISO: *3200*

Metering: *Multi-segment (Evaluative/Matrix)*

White Balance: *AWB*

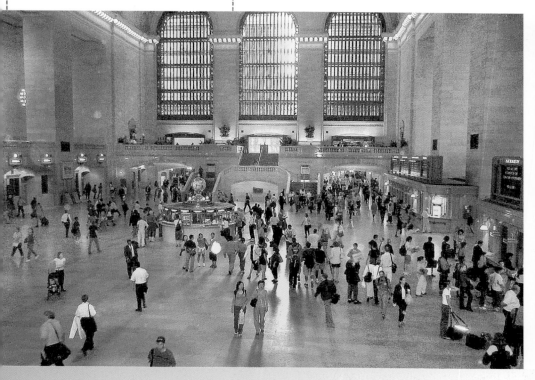

1.2 Controlling the Amount of Light

Aperture and Depth of Field

Tools:

- Aperture Priority Exposure Mode
- Zoom Lenses (to vary focal length)

While ISO controls the sensor's sensitivity to the light that comes into the camera, the aperture and the shutter speed control the amount of light that comes through the lens to register on the sensor.

Aperture refers to the diameter of the opening in the lens through which light travels when an exposure is made. The bigger the opening, the more light the lens will allow. The aperture is described as an f/number, such as f/8, and can be adjusted to permit more or less light. Higher f/numbers produce smaller apertures, so that f/8 is a narrower/smaller opening than f/4, and f/16 is narrower than f/8.

Aperture Settings (f/stop)

The aperture can be adjusted according to what are called stops—variable-sized openings that are factors between the maximum (widest) and narrowest (minimum) offered by the lens. Each successive f/stop either doubles

the diameter, or cuts it in half, depending on whether you are increasing aperture (going from a higher to a lower number) or decreasing it (going from a lower to a higher number).

Aperture is a way to control light volume, but it also plays a critical role in the depiction of sharpness through the picture space. This visual relationship of near to far subjects is known as depth of field. A narrower aperture—all other things such as the focal length of the lens and the distance between the camera and subject being equal—will yield more sharpness throughout that space, so that the entire scene looks sharp. Conversely, a wider aperture will yield less of a range of sharpness from near to far, so that you can selectively focus on one part of the scene while allowing other portions to go somewhat out of focus.

This ability to control sharpness, and the choices made in aperture settings, is a key image effect—one of the most creative aspects of photography. As demonstrated in the photos to the right, it has a profound effect on the image and how you depict subjects within the context of the overall scene, and can be examined and applied critically by using the depth of field preview function on your DSLR.

Exposure Mode: *Aperture Priority*

Aperture: *f/22*

Shutter Speed: *1/60 second*

ISO: *200*

Metering: *Multi-segment (Evaluative/Matrix)*

White Balance: *Daylight*

Focal Length: *24 mm*

Shallow depth of field can be used to create visual attention on the foreground subject by having the background sharpness drop off (go soft). To make this plant stand out from the many similar ones behind it, a shallow depth of field was used. Its form is echoed, but the soft focus makes the background plants reinforce, not compete with, the subject in the frame. A visual relationship has been produced by using a telephoto lens set to a wide f/stop, allowing us to pay close attention to one plant among many.

Exposure Mode: *Aperture Priority*

Aperture: *f/2.8*

Shutter Speed: *1/1250 second*

ISO: *200*

Metering: *Center-weighted Averaging*

White Balance: *Cloudy*

Focal Length: *50 mm*

1.3 Shutter Speed

Controlling Light and Motion

Tools:

- Tripod
- Shutter Priority Exposure Mode
- Neutral Density Filter

Exposure Mode: *Aperture Priority*
Aperture: *f/8*
Shutter Speed: *2 seconds*
ISO: *100*
Metering: *Multi-segment*
White Balance: *AWB*
Tripod

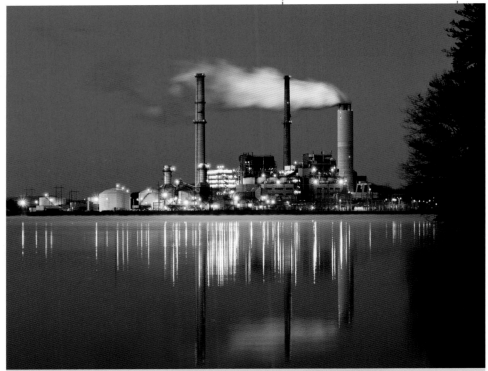

Using a tripod, the photographer selected a narrow aperture to help insure sharpness throughout the scene, and a low ISO, to reduce potential noise. Since the dawn was still relatively dark, a long shutter speed was required by the camera to allow enough light for proper exposure. Because the shutter was open for two seconds, the steam from the smokestack was captured in blurred movement, rather than frozen in a split second of time. © Kevin Kopp

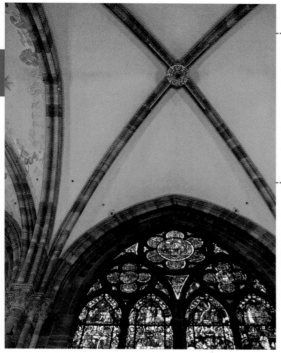

Exposure Mode: *Program*
Aperture: *f/2.8*
Shutter Speed: *1/15 second*
ISO: *800*
Metering: *Center-weighted Averaging*
White Balance: *Daylight (color cast corrected in processing)*

did u know?

1/30 second is considered slow because it is commonly considered the longest speed at which most people can handhold a camera without the image showing some shake (blur) caused by the photographer's hand/body motion. This might change if you are using a form of built-in image stabilization (lens or camera), in which case you might be able to get by with a 1/15 or possibly 1/8 second exposure.

The shutter is a type of curtain inside the camera body that opens and closes when you press the shutter release. Its speed is the length of time the shutter stays open to receive the light coming through the lens. That time frame is often only a fraction of a second, such as 1/500 (fast) or 1/8 (slow) for examples, although it can be several seconds or longer. Obviously, longer (slower) shutter speeds allow more light than shorter (faster) ones.

Since controlling light requires a balance between ISO, aperture, and shutter speed, using slow shutter speeds means you should be able to set ISO to a lower number, a benefit of which is reduced noise. Longer shutter speeds in less than dim light gener-

ally allow you to set a narrower aperture as well, which means you have a chance to increase depth of field.

Shutter speed also has an effect on image quality, since slow shutter speeds can lead to blurred images. This is because everyone's hands will move to some degree—some people more than others—when handholding a camera. Though the lowest handholdable shutter speed differs depending on how steady you are and whether your lens (or camera) has an image stabilization system, the borderline is generally at or below 1/30 second.

Exposure Mode: *Shutter Priority*
Aperture: *f/22*
Shutter Speed: *1/2 second*
ISO: *100*
Metering: *Center-weighted Averaging*
White Balance: *Daylight*

Fast and Slow Image Effects

Not only does shutter speed help determine the amount of light used in the exposure, it also allows you to choose how to depict motion. When shooting an object in motion—a flowing stream, an athlete in action, or cars on the highway, for examples—a shutter speed longer than 1/30 second can create a continuum of motion rather than an isolated moment frozen in time. (Slow shutter speeds also come in handy when shooting with flash, where slow sync can help bring in more of the available light during exposure.)

Fast shutter speeds, on the other hand, freeze motion in ways the eye cannot. Today's digital cameras have very fast shutter speeds (some are 1/8000 second) at up to eight frames per second. This means that you can take a series of pictures that splits time into fractions too small to be seen without a camera. It can show us a baseball stopped in flight as it leaves the pitcher's hand, a diver just as he or she cleaves the water, or a child in midair while playing with a jump rope (right, top).

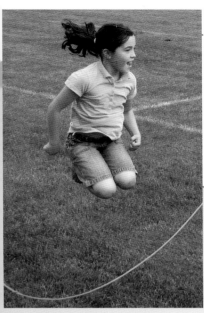

Exposure Mode: *Shutter Priority*

Aperture: *f/5.6*

Shutter Speed: *1/1000 second*

ISO: *400*

Metering: *Multi-segment (Evaluative/Pattern)*

White Balance: *Daylight*

Using a fast shutter speed of 1/1000 second (and a fast framing rate for making a sequence of shots), I was able to catch this girl in midair with no motion blur as she jumped rope. I raised ISO to 400 in order to keep the photo properly exposed at this aperture/shutter speed combination.

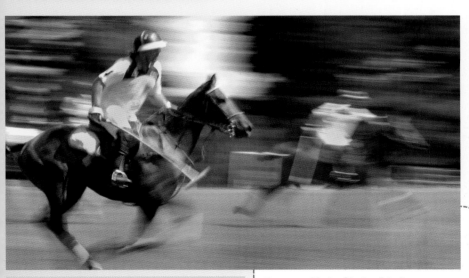

By combining the use of a slow shutter speed and panning, which is a technique of moving the camera to follow the motion of a subject across the field of action, I was able to depict the action of this polo match. A Neutral Density filter was also used to block some light, allowing me to use a slower shutter speed to achieve the effect.

Exposure Mode: *Shutter Priority*

Aperture: *f/22*

Shutter Speed: *1/8 second*

ISO: *200*

Metering: *Multi-segment (Evaluative/Pattern)*

White Balance: *Daylight*

Neutral Density Filter

1.4 Determining Equivalent Exposu

How to Create Different Photographic Effects

As we have detailed, exposure is a balancing act with three factors determining the amount of light in your photograph: ISO, aperture, and shutter speed. The designations for each of these components are not arbitrary—they are an interdependent set of controls where changing one changes the others, like an equation where you are seeking balance between all the factors.

Modern cameras allow you to make fractional changes in these settings, but to simplify matters (I am not by any measure a math wiz), let's say you double and halve the values. For example, an aperture of f/8 lets in half the light as that of f/5.6, but twice as much as f/11; while f/11 allows twice as much light to pass as f/16. On the shutter speed side of the ledger, a setting of 1/125 second permits only half the amount of light as 1/60 second, but twice that of 1/250 second, and four times the amount of light

as 1/500 second. Similarly, ISO 200 is twice as sensitive to light as ISO 100, and half as sensitive as ISO 400, which in turn is half as sensitive as ISO 800.

Changing any of these factors by one increment alters the brightness by one exposure value (EV), often referred to as a stop. Consequently, you can produce the same amount of light in your exposure by using different combinations of these three settings. This is known as equivalent exposure. A camera set to ISO 100, f/8, 1/125 second will deliver the same EV as when set to ISO 100, f/5.6, 1/250 second; or to ISO 200, f/11, 1/125 second. An increase or decrease with regard to EV in any of the factors requires a reciprocal change in one of the others to maintain equilibrium between all three; e.g. a change of +3EV in aperture would require a total change of -3EV in either shutter speed and/or ISO. And by equilibrium, I mean the same amount of light, or the same overall exposure.

However, and this is a key concept, the way you balance different apertures and shutter speeds will generate different image effects. As we have seen previously, aperture controls focus effects, and shutter speed controls motion effects.

Exposure Mode: *Aperture Priority*

Aperture: *f/11*

Shutter Speed: *1/250 second*

ISO: *100*

Metering: *Multi-segment (Evaluative/Matrix)*

White Balance: *AWB*

did u know?
You make a choice about image effects each time you make a photograph. When you adjust the aperture, you can shorten or lengthen the depth of field, which changes the relationship between foreground and background subjects within the frame.

Exposure Mode: *Aperture Priority*

Aperture: *f/5.6*

Shutter Speed: *1/1000 second*

ISO: *100*

Metering: *Multi-segment (Evaluative/Matrix)*

White Balance: *AWB*

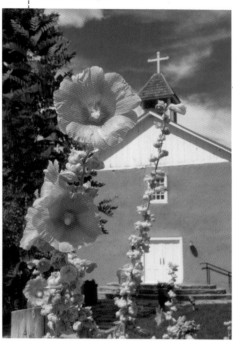

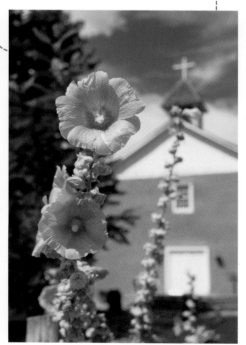

Both of these flower photos have the same amount of light exposing them. However, changing the aperture alters the depth of field, allowing you to choose whether you want to keep the background church in sharp focus or not. The photo to the left was photographed with a wider aperture than the photo above.

Exposure Value (EV)

Photographers use the term EV in several different ways. But it always has to do with how light is translated to photographic terms. Some of the ways in which it is referred to by photographers include:

• The combination of aperture and shutter speed that creates a certain exposure at a certain ISO. For example, EV10 might mean f/11 at 1/125 second or f/8 at 1/250 second, both at ISO 100. Or, when ISO is set to 200, it could subsequently mean f/16 at 1/125 second or f/8 at 1/500 second.

• EV is also used to denote a change in exposure level, either because the quantity of light in the scene gets brighter or dimmer, or because the combination of aperture, shutter speed, and ISO setting is adjusted to allow a certain amount of light through the lens to make the exposure.

• It is also commonly used to quantify the amount of exposure compensation being used (as, for examples, +2EV or –3EV) as a way to override certain automatic exposure readings.

So, think of EV as shorthand for how you deal with changes in light levels or light recording in photography.

The light was fairly low inside this chapel, and I did not want to be rude by using flash. My exposure at ISO 100 would yield a shutter speed slow enough to produce blur due to camera shake. To get a handholdable speed of 1/40 second at the widest aperture the lens afforded, I raised the ISO to 1600. This is how equivalent exposures are used—to enable you to capture the scenes you want with the image effects you want.

Exposure Mode: *Program*
Aperture: *f/3.2*
Shutter Speed: *1/40 second*
ISO: *1600*
Metering: *Multi-segment (Evaluative/Pattern)*
White Balance: *AWB*

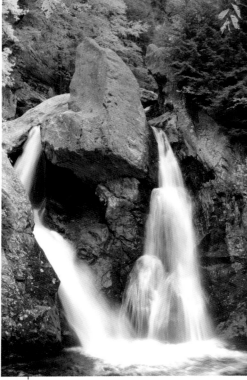

Exposure Mode: *Shutter Priority*

Aperture: *f/6.3*

Shutter Speed: *1/125 second*

ISO: *200*

Metering: *Multi-segment (Evaluative/Pattern)*

White Balance: *AWB*

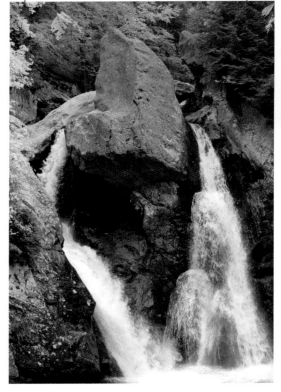

Exposure Mode: *Shutter Priority*

Aperture: *f/22*

Shutter Speed: *1/8 second*

ISO: *200*

Metering: *Multi-segment (Evaluative/Pattern)*

White Balance: *AWB*

This waterfall was photographed twice using different shutter speeds. The exposure for both is the same (equivalent), but the result is entirely different in terms of image effects and artistic interpretation. The narrower aperture resulted in a slower shutter speed to make the water above appear like a smooth ribbon, while the wider aperture caused a faster shutter speed and shows the splashing droplets of the falls (left).

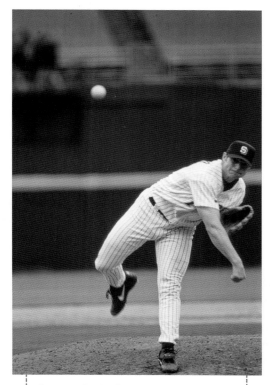

When you make aperture decisions, you are determining just how sharp, or un-sharp, the background will be. In some cases you'll want to include the entire background in sharpness to give the sub-ject context. In others, you might want to isolate the subject by blurring the back-ground, or at least make the background a less prominent part of the image.

When you want to freeze the action within a photo, set a shutter speed that is fast enough to do the trick. Slow shutter speeds, on the other hand, capture mo-tion in a more blurred rendering, giving a flowing sense of the occurring action.

The capability to work with equivalent ex-posure means that you have the ability to select which image effects to control. In the shot of a pitcher in action (right), the decision was made to photograph the ball in mid-flight, which necessitated a very fast shutter speed (1/2000 second). That in turn yielded a wide aperture and shallow depth of field.

Exposure Mode: *Shutter Priority*
Aperture: *f/4*
Shutter Speed: *1/2000 second*
ISO: *400*
Metering: *Multi-segment (Evaluative/Pattern)*
White Balance: *AWB*

1.5 Program Exposure Mode

Shifting to Quickly Control Photo Effects

Tools:

- Program Exposure Mode with Program Shift Option.
- All Metering Modes.

Once the camera makes a reading in Program mode, you can turn a camera dial to shift either the aperture and/or the shutter speed. If you change aperture, the camera will change shutter speed to produce an equivalent exposure (see page 26). If you change shutter speed, the aperture will correspondingly change.

Most advanced photographers think of Program exposure mode as the "snapshot" mode, for use to quickly point and shoot at such events as parties or family gatherings. Program has a reputation for being the mode to choose when you simply don't want to think too much about how to record a scene.

Yet, Program exposure mode is actually quite sophisticated; it is able to take into account, among other factors, the ISO setting, the focal length of the lens, and whether or not flash is activated. While this mode is like full AUTO exposure mode in many respects, it differs because it allows complete control over the aperture and shutter speed settings when using an option known as Program Shift.

You can use Program with any of the metering patterns. A major advantage to using this exposure mode is the ease it affords in rapidly controlling image effects based on whether you want to alter aperture or shutter speed in a given situation.

I often use Program mode when making casual and fun snapshots, especially with a fairly wide-angle lens. At an amusement park with my lens set to a focal length of 28mm, I used Program Shift to control depth of field on different photos (right).

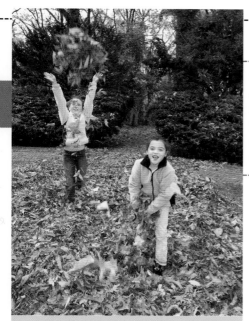

Exposure Mode: *Program*
Aperture: *f/4*
Shutter Speed: *1/160 second*
ISO: *200*
Metering: *Multi-segment*
White Balance: *Daylight*

You rarely have time to contemplate camera settings when photographing kids at play. That's a time when Program mode comes in very handy.

Exposure Mode: *Program*
Aperture: *f/5.6 shift to f/16*
Shutter Speed: *1/60 second shift to 1/8 second*
ISO: *100*
Metering: *Center-weighted Averaging*
White Balance: *Daylight*
Tripod

Exposure Mode: *Program*
Aperture: *f/8 shift to f/16*
Shutter Speed: *1/250 second shift to 1/60 second*
ISO: *100*
Metering: *Multi-segment (Evaluative/Matrix)*
White Balance: *Daylight*

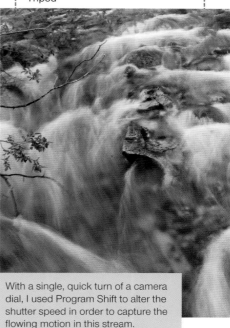

With a single, quick turn of a camera dial, I used Program Shift to alter the shutter speed in order to capture the flowing motion in this stream.

1.6 Highlight Overexposure Warnin

Beware of the Blinkies

Tools:

- Playback Menu
- Highlight Warning
- Exposure Compensation
- Spot Metering

The main culprit in poor image quality is overexposure. In many lighting situations, the sensor can record bright areas with little problem. But when too much light reaches the sensor, the individual photosites become overwhelmed and the camera's electronics lose the ability to record detail. You end up with a white, blank area within the image.

There are several types of situations when you may not be pleased with your camera's rendering of highlights: High contrast conditions when there are deep shadows and very bright areas; sunlit snow scenes or others where the image is composed primarily of bright whites; or those pictures where you simply make the wrong exposure reading and allow too much light to enter the lens. You might find that you want to send the image right to the trash bin in most such cases.

One of the best ways to judge if overexposure has occurred is to utilize the highlight warning system found in many cameras. This allows you to clearly see areas of overexposure during image playback, or even in instant review immediately after the image is recorded. The warning is evident in the form of "blinkies"—a color that flashes on and off within overexposed areas of the picture. These blinkies are often black, but may also be other colors (red is shown in the example on page 36).

My suggestion is to leave this highlight warning on at all times. If the area that blinks is large and takes up important areas within the frame, the system is telling you to adjust exposure and reshoot the picture. You can decrease overall exposure in several ways: Close down the aperture and/or choose a faster shutter speed in Manual exposure mode; set minus (–) EV as exposure compensation when in autoexposure modes; or take a new reading making sure that you include more of the bright areas in your metering (see pages 84–95 for details on metering patterns and highlight area readings).

Exposure Mode: *Aperture Priority*
Aperture: *f/11.5*
Shutter Speed: *1/125 second*
ISO: *100*
Metering: *Spot, read from white wall (highlight)*
White Balance: Daylight
Exposure Compensation: *+1.5EV*

This scene above is dominated by a bright white exterior wall and contains contrasting shadows—not the best situation to use multi-segment metering. So normally I would read from the wall using the camera's spot meter, and I'd set +1 or +1.5EV exposure compensation.

It may seem counterintuitive to add plus (+) EV to a bright scene. But the light meter is calibrated to read values as middle gray (between white and black). When you aim the spot meter at a bright area, you are in essence telling the camera to read that area as gray, which makes the scene darker. So, +EV counterbalances the tendency of the meter to create an exposure that may otherwise record white as gray, and it comes in handy when bright white areas dominate the frame.

If you notice that your camera's overexposure warning is blinking, as depicted here by red areas, you can correct the exposure by re-reading the scene and taking the shot again.

As a contrasting example, the photos on this page simulate the opposite effect, which could occur if the spot meter were pointed at the darker areas of roof or shadow. The spot meter would read those dark areas as middle gray, which is brighter than the actual shadow, thus overexposing the brighter areas of the image. The photo above shows how the blinkies would display on your LCD, and the photo below shows what the image would look like if you went ahead and made that exposure.

Note: Also use spot metering when you want to deeply saturate a particular bright hue by spot reading from that color in the scene.

Exposure Mode: *Aperture Priority*
Aperture: *f/8*
Shutter Speed: *1/125 second*
ISO: *100*
Metering: *Spot, read from shadow area under roof, exposure locked and recomposed*
White Balance: *Daylight*

You don't normally need to be
concerned if only small areas of
blinkies are present, especially
if that area is encompassed by
other, deeper tones. In the picture
above, a bright façade of a build-
ing does exhibit some overex-
posure (shown in the cropped
detail, right), but it is not a prob-
lem when viewed in the context
of the overall scene.

1.7 Reviewing Histograms

Objectively Analyze for Proper Exposure

The LCD not only displays images for re- view after exposure (and before exposure in many cameras with a Live View function), it is usually able to show a graphic display of the tonal distribution within the photograph, meaning it shows the different light values from very dark (left side of graph) to very bright (right side). This is called a histogram. It is frequently accessible by going into Playback mode and toggling through options controlled by an Info button. Some cameras feature "live" histograms, which means the displays are available prior to exposure, sort of an in-camera light meter.

The histogram can be an effective guide to exposure, but quite frankly, I try not to follow it slavishly. Some photographers feel that a histogram has to completely fill the graph from the left to right edges with no cutoffs—

also known as clipping—where the graph hits the left or right side abruptly, indicating loss of tonal values. However, it is not uncommon to find a strong image that has a less than stereotypically optimal histogram. Expressive photographs are those that record the scene the way your mind's eye saw it, and that doesn't always result in a "good" histogram.

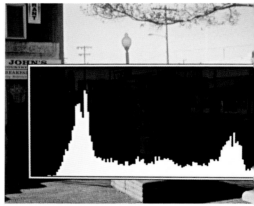

© Frank Gallaugher

did u know?
Examining an image closely on an LCD under certain lighting conditions, such as bright sunlight, might be difficult. It is literally hard to see the details of the picture. That's when the histogram readout comes in handy.

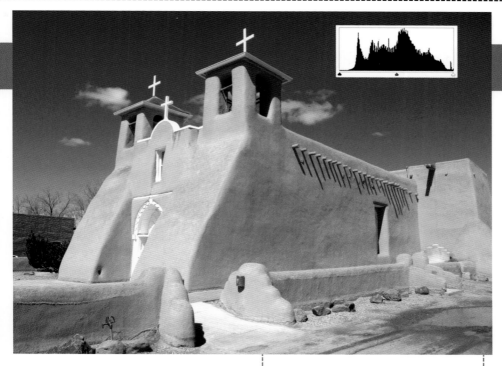

Exposure Mode: *Manual*
Aperture: *f/7.1*
Shutter Speed: *1/640 second*
ISO: *100*
Metering: *Multi-segment (Evaluative/Matrix)*
White Balance: *Daylight*

The other side of the argument is that interpretive exposures can be created when working on the image later in the workflow using image-processing software in your computer. In fact, the more information you capture— the fuller the histogram, without clipping— the more leeway you have in processing. In general, if you are shooting RAW files, you will process them using a software program in your computer. Your goal is to capture as much image information from the scene as possible, from detail in the dark shadows to texture in the bright highlights, all of which you can readily enhance as needed. If shooting JPEGs, on the other hand, because you want to do minimal or no processing with computer software, try to get the effect you want when you make the picture.

The well-exposed photo of an adobe church above shows a "normal" or "happy" histogram, where all the tones are arrayed across the gamut (range) of the graph, with no clipping or loss of values shown by the fact that there is no cutoff of information at the top or sides of the graph. This shot was exposed perfectly in the field, and will yield an excellent print without much processing.

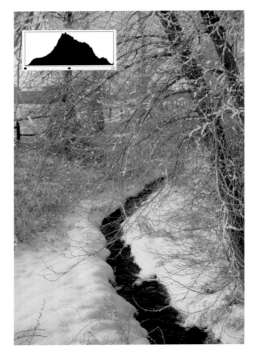

Though this histogram for the picture of a snowy stream displays an almost perfect bell-shaped curve (right), pay attention to how the graph is bunched toward the center, showing a concentration of middle-toned values. An image like this can be processed later to show more contrast (below), or you could add a stop or more exposure to lighten the whites if you reviewed the histogram in the field and decided to reshoot the photo.

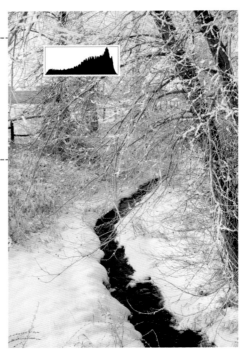

Exposure Mode: *Aperture Priority*
Aperture: *f/11*
Shutter Speed: *1/800 second*
ISO: *800*
Metering: *Center-weighted Averaging*
White Balance: *Daylight*

This version was processed in Photoshop by working with the Levels tool, increasing brightness and contrast, then slightly burning the highlights—adjustments that caused the histogram to shift to the right.

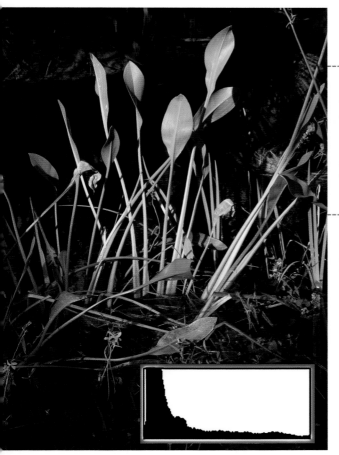

Exposure Mode: *Aperture Priority*
Aperture: *f/16*
Shutter Speed: *1/125 second*
ISO: *100*
Metering: *Spot, read from brightly lit leaf, exposure locked and recomosed*
White Balance: *Daylight*
Exposure Compensation: *+0.5EV*

> **Note:** The histograms in these examples are copies created in Photoshop that show what you would see in your LCD after exposure (or prior to exposure if your camera has a live histogram feature).

The picture above illustrates another type of histogram, showing an imbalance of tones to the left (dark) and some clipping of shadow detail. Its heavily underexposed character might have led me to reject and even delete this image had I merely looked at the histogram without any sense of what the image should look like. But this is exactly the exposure I wanted in this shot, with the highlighted areas standing out against a very dark background. It demonstrates that an aesthetic sense about photography and creative decision–making are not always governed by objective measurments. In fact, many extremely interesting images are characterized by a "poor" (unbalanced) histogram.

1.8 Bracketing for Night Scenes

Tools:

- Autoexposure Bracketing (AEB)
- Exposure Compensation
- Manual Exposure Mode
- Tripod

Exposure bracketing is usually a sequence of photos—most often a quantity of three—where one photo is recorded using the camera's recommended light reading, another is recorded with added light, and the third with less than the recommended amount of light. A tried and true technique to capture well-exposed images, bracketing is handy when there is a great deal of contrast in the scene (a broad range between light and dark), or when you are not sure which exposure settings to use. This can often be the case with pictures made at night with artificial light.

The bracketing function is usually found within the camera's menu system. You can also select continuous shooting mode on many camera models, which will allow you to record the three bracketed pictures with a single press of the shutter release.

If your camera does not have this feature, try shooting in an autoexposure mode. Bracket with the exposure compensation control,

holding the camera in the same position, and setting it differently for each shot. Or, switch to Manual exposure mode and move your camera's control/command dial to make different exposures as you shoot consecutive images. You can choose to do this on a tripod or not, depending on how critical you are about framing and how steady you can hold the camera in the available lighting conditions.

Note: If the camera is set to Aperture Priority while bracketing, the shutter speed will change for each exposure; if using Shutter Priority, the aperture will change during the sequence.

Exposure bracketing is like insurance when shooting under tricky lighting conditions, especially at night. You might well record an accurate exposure by using spot metering and exposure compensation, but you can also make a center-weighted averaging meter reading and then bracket to choose one of the resulting three images as the preferred exposure.

In the bracketed pictures to the right, the shutter speed changed from 1/125 second (top), to 1/60 second (middle), to 1/30 second (bottom). The two faster exposures are acceptable, but the image shot at 1/30 second is overexposed and probably will not be easy to save in image processing in the computer.

Exposure Mode: *Aperture Priority*
Aperture: *f/4*
Shutter Speed: *Variable*
ISO: *320*
Metering: *Center-weighted Averaging*
White Balance: *AWB*

1.9 Good News; Bad News

Using High ISO Settings

Tools:

- ISO settings
- Noise Reduction (NR) Filtration (in camera)

Digital cameras have developed an amazing sensitivity to light over the past several years, with some ISO ranges extending to a setting of 25000 and higher! In some respects, that's quite exciting. But there are compromises that detract from image quality as you stray from the sensor's native sensitivity (the lowest ISO setting), and these compromises increase substantially the higher you go. Any increase adds to visual noise, more grain, image artifacts, increased contrast, color shifts, and discontinuities of color. The golden rule for ISO is to keep the setting as low as you can whenever you can.

Your D-SLR will usually not show noticeable noise at speeds up to ISO 800. On the other hand, at settings above ISO 800, you should turn on the noise reduction filter if your camera has one.

There are advantages to raising the ISO when needed. In low light without flash, you might not be able to shoot with a fast enough shutter speed to keep the camera steady. Increasing the ISO setting opens more photo opportunities in low light situations when you don't want to (or can't) use flash or a tripod.

However, if you do use flash, raising the speed also extends the flash range. If the built-in flash on your camera gives you flash coverage of about 8 feet at ISO 100, adjusting up to ISO 400 extends that range to about 12–16 feet.

The interior of the church in the upper photo to the right was quite dark. I first set the ISO to 400, but I noticed that even with a wide open aperture, the shutter speed would be 1/4 second—too long for a handheld shot, even with a vibration reduction (VR) lens. So I made the picture by switching to ISO 1600. Though this caused a few image artifacts and some noise to appear in the darker areas, it was the only way to get a steady image. The details and various colors and lines in the scene helped mask some of the artifacts, but they are more evident when the photo is enlarged.

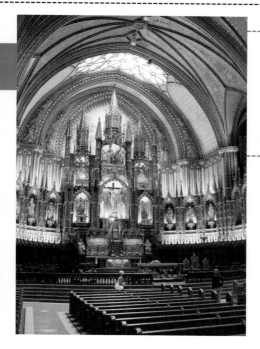

Exposure Mode: *Program*
Aperture: *f/2.8*
Shutter Speed: *1/15 second with a vibration reduction lens*
ISO: *1600*
Metering: *Multi-segment (Evaluative/Matrix)*
White Balance: *AWB*

If your camera has high ISO options (particularly above 800), it undoubtedly has some form of noise reduction filter (NR) built in. This filter will often become active automatically at certain ISO settings. In addition, many D-SLRs include the ability to set the level of NR through their menu system. But as the level of NR increases, more smoothing or blurring of pixel-edge contrast occurs, resulting in less image sharpness.

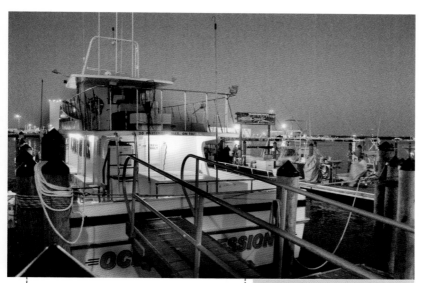

Exposure Mode: *Program*
Aperture: *f/3.8*
Shutter Speed: *1/10 second*
ISO: *1200*
Metering: *Multi-segment (Evaluative/Matrix)*
White Balance: *Daylight*
Tripod

A high ISO was set to photograph this fishing boat in low light. A low level of noise reduction was applied, but there are still some artifacts and noise in the sky and in dark portions of the image (see next page).

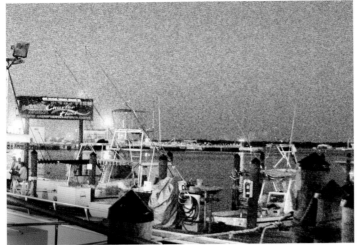

This image is a cropped portion of the fishing boat scene (from the previous page) that has been enlarged for easier viewing. This shows more clearly the amount of noise created in this picture. Notice the difference in the photo below that shows the same area of the shot but with a higher level of NR applied, and therefore has less noise (but with a smoother, softer look).

You can always experiment with your camera settings to see how increasing ISO affects your image quality. Test various kinds of scenes, because an ocean view with vast sky will probably handle the increase differently than a forest landscape, an urban scene, an interior shot, or a portrait. All will lose image quality; but some lose more than others. Most recent cameras produce excellent results up to and including ISO 800, and I would not hesitate to shoot at that speed for interior and low light scenes.

The scary character (far right) was recorded at the camera's default NR, which is automatically set whenever ISO is above 400 (unless default is changed in the camera's Custom Functions).

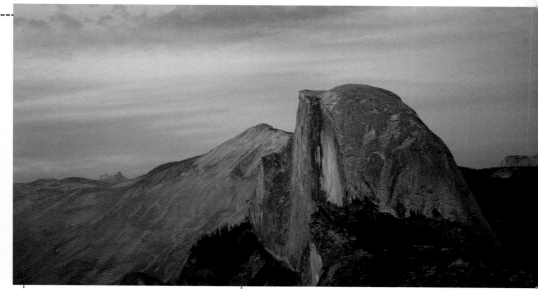

Exposure Mode: *Aperture Priority*

Aperture: *f/5*

Shutter Speed: *1/25 second*

ISO: *100*

Metering: *Multi-segment (Evaluative/Matrix)*

White Balance: *Daylight*

did u know?

Whenever possible in low light, it is best to use a tripod for optimal image quality rather than shifting to a higher ISO. In this mountain landscape (above), the sun had set below the horizon, but a tripod allowed for a sharp picture at a longer exposure (therefore less need for higher sensitivity) than would be possible if handholding with this long-range telephoto lens.

Exposure Mode: Program

Aperture: f/3.5

Shutter Speed: 1/25 second with VR lens

ISO: 800

Metering: Multi-segment (Evaluative/Matrix)

White Balance: Daylight

© Grace Schaub

1.10 Manual Exposure

Tools:

- Manual Exposure Mode
- Center-weighted Averaging or Spot Metering
- Stitching/Merge Software to Produce Panoramic Images

The white square in the middle represents optimal exposure, with each of the white vertical rectangles representing full stops of plus or minus EV.

Some beginning photographers approach Manual exposure with a bit of fear, but it really is not as complicated as first imagined. In fact, it is a very handy tool for controlling exposure. When you frame the scene in Manual mode, you will notice a scale in the viewfinder (or sometimes also in the back LCD or a top panel). The scale is often marked by a negative and a positive endpoint, with the midpoint clearly defined (perhaps by a 0 or a large hash mark). To make an exposure based on what the camera's metering system recommends, you must adjust the aperture and/or shutter speed until the scale is balanced, or midway between the two endpoints.

Some folks prefer Manual exposure simply because they like to fiddle with the settings. But on a more useful note, Manual is particularly useful in a couple of different situations:

1. When you want to change the exposure quickly. You can easily make an exposure with more or less light in Manual just by adjusting the aperture or shutter speed. (In autoexposure modes, you might have to reread and lock exposure, or resort to using exposure compensation.)

2. When you want to keep exposure constant regardless of where you point the camera. This can come in handy when lighting does not vary and you want to shoot without changing settings. I often do this when I am working with one subject or scene in which the light is steady and I want to just walk around the area and shoot without considering the exposure settings. This has a certain liberating feel to it.

Manual mode can be used with any of the metering patterns. I use it with center-weighted averaging and spot to identify the crucial areas for exposure before recording.

If I want to spot read on a color for saturation, I leave the setting as is; if I am spotting on bright white, I adjust settings to move the indicator to +1EV. I also check the highlights with the highlight warning playback in my camera to insure that I have bright areas well under control. If overexposed, I can adjust quickly using the dials on the camera rather than making another reading and locking exposure or using the exposure compensation control.

Exposure Mode: *Manual*
Aperture: *f/11*
Shutter Speed: *1/250 second*
ISO: *100*
Metering: *Center-weighted Averaging*
White Balance: *Daylight*

I misread this scene the first time I recorded it because of the light green limbs in front of the dark trunks, which caused the limbs to become overexposed. But since I was using Manual exposure mode, I was able to adjust the shutter speed in no time with a quick turn of the camera's command dial to the minus exposure side, producing just the exposure I desired.

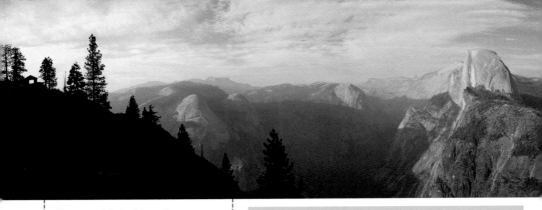

Exposure Mode: *Manual*
Aperture: *f/8*
Shutter Speed: *1/60 second*
ISO: *200*
Metering: *Center-weighted Averaging*
White Balance: *Daylight*

did u know?
One situation where you should always utilize Manual exposure mode is when shooting panoramic scenes for stitching. This insures that the light will be consistent from frame to frame, and reduces the chances of obvious seams appearing in the final stitched image. Every one of the nine frames in this panorama photo from Glacier Point in Yosemite National Park was exposed at f/8 and 1/60 second.

Since the level of light on this dark morning was steady, I set the camera to Manual exposure mode, made a reading from the fog-lit area with center-weighted averaging metering, and checked it on my playback review. The camera overexposed slightly, so I dropped the metering indicator to −1EV. It captured just the mood I wanted right out of the camera with minimal processing later.

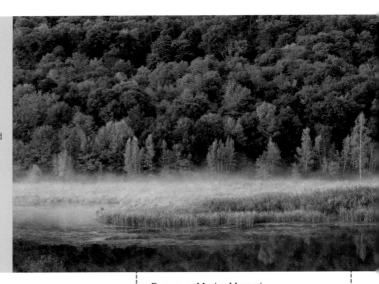

Exposure Mode: *Manual*
Aperture: *f/3.2*
Shutter Speed: *1/4 second*
ISO: *200*
Metering: *Center-weighted Averaging*
White Balance: *Daylight*
Tripod
-1EV from camera-recommended reading

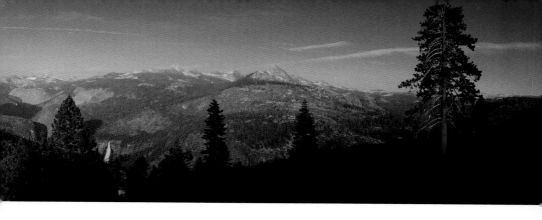

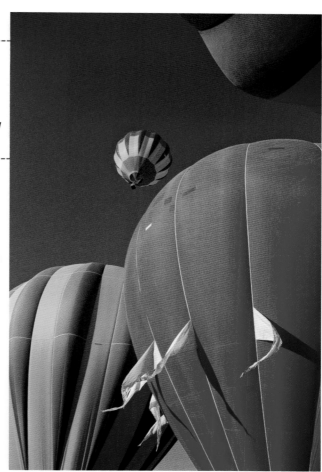

Exposure Mode: *Manual*

Aperture: *f/11*

Shutter Speed: *1/12 second*

ISO: *200*

Metering: *Center-weighted Averaging*

White Balance: *Daylight*

About 100 balloons were to be set aloft in a short period of time during this sunrise rally, and I wanted to get as many shots of them as possible. Once I had read the light and checked the exposure by reviewing results in playback, I switched to Manual mode and shot the entire event without changing settings, working quickly and reacting spontaneously to the action around me.

Light is always changing, and different types of light illuminate objects in a variety of ways. It is helpful to be aware of the photographic possibilities that these different types of light afford. In addition, you should be aware that what your eyes see when light strikes a subject may be quite different than what the sensor records. Reconciling differences between our eyesight and the images produced by digital cameras creates an understanding of how to bridge what might otherwise be a wide gap.

Knowing how photographers describe light is handy to help you interpret the light, as well as to help make choices about metering patterns and exposure modes. Categorizing types of light helps you optimize exposure for different subjects and scenes.

2.1 Light from Different Sources

Light is often defined by its source. Given that every moment is unique, and that light is always particular to the time of day, weather, and environment, here are some terms used commonly in photography.

Natural Light

Natural light is light from the sun, whether it is direct or reflected rays (below). It is commonly referred to as daylight.

Available Light

Sometimes referred to as ambient light, this type is light that exists in the scene. It can be natural or artificial light, but is not added specifically by the photographer for the photograph. It can be anything from sunlight to incandescent to light that streams through a window (opposite page, above) or comes from the flame of a candle. In general, this type of lighting requires that you take the light source into consideration and not overexpose the image by metering on the darker areas within the frame.

Exposure Mode: *Aperture Priority*
Aperture: *f/8*
Shutter Speed: *1/125 second*
ISO: *100*
Metering: *Multi-segment (Evaluative/Matrix)*
White Balance: *AWB*

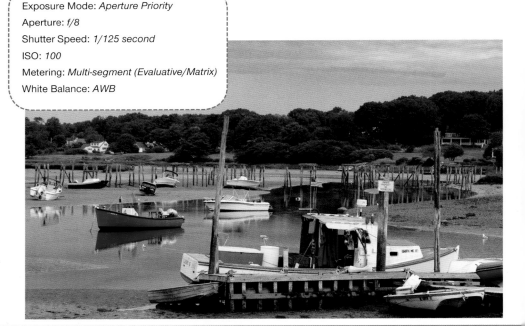

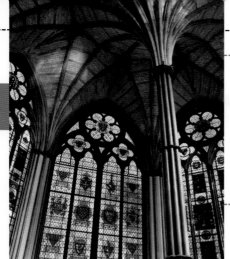

Exposure Mode: *Shutter Priority*
Aperture: *f/4*
Shutter Speed: *1/200 second*
ISO: *200*
Metering: *Center-weighted Averaging, read from center window panes.*
White Balance: *Daylight*

The dappled light in the scene above is challenging because the detail in the stained glass window is as crucial to what I was trying to record as the detail in the stone arches and supports. To insure that detail was captured in the beautiful windows, I took a center-weighted averaging meter reading, placing one of the windows in the center of my frame, and then locked exposure and recomposed. Later, in processing, I was able to "bring back" more detail in the darker areas of the building interior.

Artificial Light

Artificial light is illumination provided by a filament bulb, fluorescent light, or flash. The shop window pictured below was photographed at night. The interior consists of mixed lighting from fluorescent lamps, daylight spots, and tungsten floor lamps. After experimenting, I settled on Fluorescent as the best white balance setting.

Exposure Mode: *Shutter Priority*
Aperture: *f/7.1*
Shutter Speed: *1/60 second*
ISO: *1600*
Metering: *Multi-segment (Evaluative/Matrix)*
White Balance: *Fluorescent*

2.2 The Character of Light

Its Effects on Photos

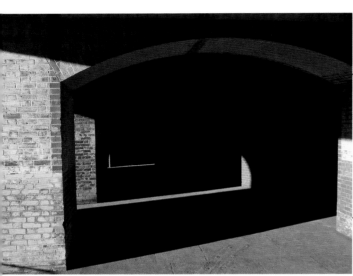

Exposure Mode: *Aperture Priority*
Aperture: *f/4*
Shutter Speed: *1/500 second*
ISO: *100*
Metering: *Center-weighted Averaging, read from brick wall at left, exposure locked and recomposed*
White Balance: AWB

Light is also defined by its character and quality, which in turn affect the ways it lights objects in a scene. Among the characteristics of light are the following:

Hard Light

Hard light creates strong shadows and contrast. It can be the light at high altitudes unimpeded by haze or dust, the light from an artificial source placed close to the subject, or any strong or directional light that brings out the texture of a surface. The brick archway above was photographed late in the afternoon on a winter day when the light was very strong and low.

Soft Light

Soft light can be any that is diffused through curtains, clouds, or fog. The diffusion breaks up the direct beams of light so it glows. Autumn foliage shots are often associated with strong color saturation and contrast; however, this softer-looking photo was made on a foggy October morning (opposite page, near).

Warm Light

Warm light has a yellow/amber glow, usually imparted from a candle or lamp, or from the low, slanting rays of the setting or rising sun. The photo below was made as the sun set in the old town area of Strasbourg, France. No additional color bias was used, or needed.

Exposure Mode: *Aperture Priority*

Aperture: *f/4.5*

Shutter Speed: *1/100 second*

ISO: *200*

Metering: *Multi-segment (Evaluative/Matrix)*

White Balance: *Daylight*

Exposure Compensation: *+0.5EV (adds to diffuse light feeling)*

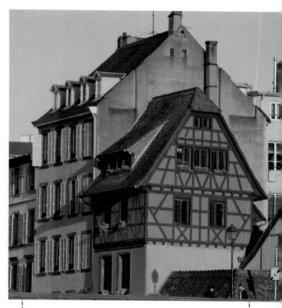

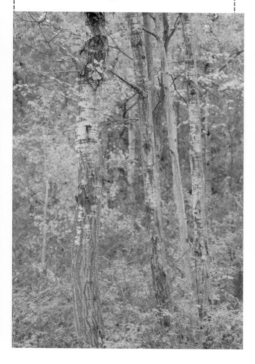

Exposure Mode: *Shutter Priority*

Aperture: *f/4.8*

Shutter Speed: *1/250 second*

ISO: *200*

Metering: *Multi-segment (Evaluative/Matrix)*

White Balance: *Daylight*

Exposure Compensation: *−0.3EV (helps create a deeper warm tone.)*

Neutral Light

A neutral light produces no intentional or naturally occurring color cast within the image—colors record as you see them. In many cases, I recommend shooting at Daylight white balance to record colors as you actually observe them, but in the case illustrated below of mixed light in the Paris subway, I relied on Auto white balance (AWB) to deliver a neutral cast.

Exposure Mode: *Shutter Priority*
Aperture: *f/2.8*
Shutter Speed: *1/30 second*
ISO: *800*
Metering: *Multi-segment (Evaluative/Matrix)*
White Balance: *AWB*

Cold Light

Cold, or blue, light can occur when subjects are photographed in the shade, under an overcast sky, or when shooting at high altitude where the cool appearance is due to an overabundance of ultraviolet light rays. The picture of the old log building (opposite, above), was made in clear, winter light at an altitude of 7200 feet. I could have warmed up the image up by using a Cloudy WB setting, but decided to retain the cool, blue light that expressed the actual way the scene looked—and how the air temperature felt—when I took the shot.

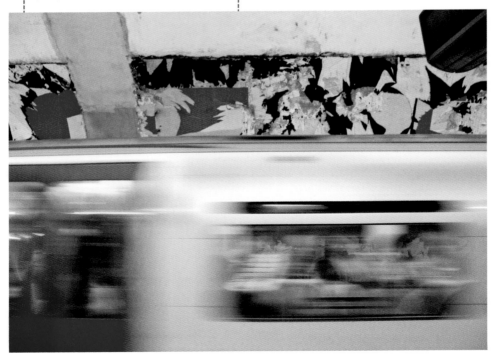

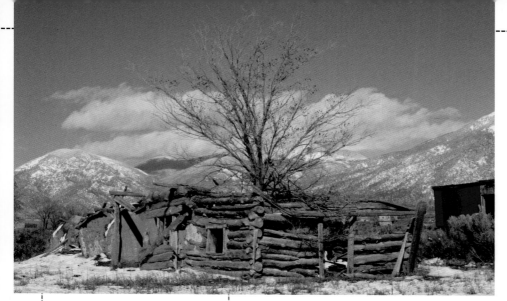

Exposure Mode: *Aperture Priority*
Aperture: *f/11*
Shutter Speed: *1/1600 second*
ISO: *400*
Metering: *Center-weighted Averaging*
White Balance: *Daylight*

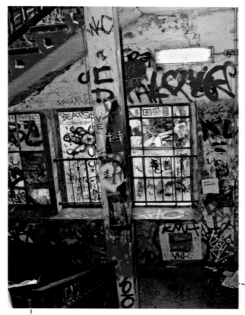

Point Source

A point source of light might define a burst of
light from a flash, a ray of light from an artificial
lamp, or even the light coming directly from
the sun. It is hard, unforgiving light that etches
the subject. I could have photographed this
painted room (right) without using a flash unit
by setting a high ISO, but the graffiti called for
a harder, more defined light.

Exposure Mode: *Program*
Aperture: *f/4*
Shutter Speed: *1/30 second*
ISO: *320*
Metering: *Multi-segment (Evaluative/Matrix)*
White Balance: *AWB*
Exposure Compensation: *−1EV*

2.3 Light from Different Directions

Tools:

- Note the location of your light source

Light is also defined by its direction; that is, the point of view of the subject in relation to the light source. Along with the most common directional terms described in this section, there are also front lighting (where the light falls over the photographer's shoulder onto the subject), top lighting (often called a "hair light" in studio lighting setups), and bottom lighting (when light comes through a glass floor, for example.) As you look at the photos throughout this book, take note of the direction of light and how it affects the texture and character of the subject.

Backlight

Backlight is when the light comes from behind the subject toward the camera, causing the subject to become dark, falling within its own shadow. In some cases, you will need to add fill flash or read directly from the darkened subject for good exposure; but in many cases, treating the foreground as a silhouette is a good choice. In the shot to the right, I pointed the meter at the bright ground to retain the deep shadows cast toward the camera position.

Exposure Mode: *Aperture Priority*
Aperture: *f/10*
Shutter Speed: *1/400 second*
ISO: *200*
Metering: *Center-weighted Averaging*
White Balance: *Daylight*

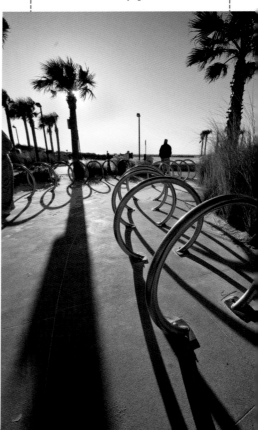

Exposure Mode: *Shutter Priority*
Aperture: *f/5.6*
Shutter Speed: *1/320 second*
ISO: *200*
Metering: *Center-weighted Averaging*
White Balance: *Daylight*

Side Light

Side light, sometimes called directional light, seems to break in from the far edges of the frame. It can often yield the most dramatic lighting, but is perhaps the most difficult to expose correctly. Sidelight is a wonderful choice for enhancing texture and shape, and to highlight a sense of spacing between subjects. In the picture above, the meter reading was made from the bright tree bark on the left side of the frame, then locked, and the scene was then reframed.

2.4 Using High and Low Key

How to Create Mood

Tools:

- Look for bright or dark lighting conditions
- Exposure Compensation

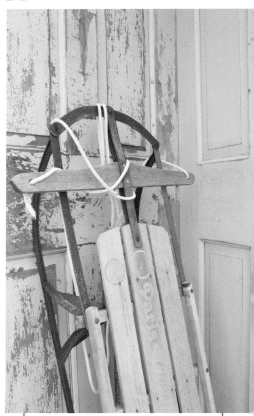

Light creates mood with color, but it also does so with the general tonal range it produces. In most scenes there is a mix of bright and dark light, creating a relatively wide range between the lightest and darkest tones. But in some cases the range of light displays a limited spectrum of tonal values—mostly light or mostly dark. Those are called keys.

High Key

High key images are dominated by bright values with little or no contrast. Such photos can be ethereal or blazing with light. Though the sled in the photo here was in the shade of a doorway, it was lit with reflective fill from an opposite wall, producing a bright-toned photo.

Exposure Mode: *Shutter Priority*
Aperture: *f/5.6*
Shutter Speed: *1/100 second*
ISO: *100*
Metering: *Center-weighted Averaging*
White Balance: *Daylight*

Low Key

Low key images are dominated by dark, somber light without much contrast. This effect can be created by shooting in the shade, in overcast conditions, or in general when the light is low and diffused. The photo below of a flower was photographed in a greenhouse on an overcast day and was underexposed even further to enhance the mood of darkness.

did u know?
When setting exposure compensation in Aperture Priority mode, the shutter speed adjusts to alter the EV. So be sure that shutter speed will be fast enough for a steady shot in such situations.

Exposure Mode: *Aperture Priority*
Aperture: *f/9*
Shutter Speed: *1/125 second*
ISO: *200*
Metering: *Center-weighted Averaging*
White Balance: *Daylight*
Exposure Compensation: *−1.5EV (helps create low key tonality in low contrast scenes)*

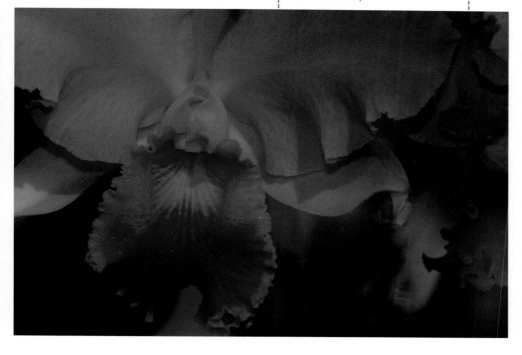

2.5 The Color of Light

How Light Temperature Affects Your Photos

Tools:

- **White Balance Controls**

- Tungsten
 (approx. 2000-3500k)

- Flourescent
 (approx. 3500-4500k)

- Auto WB AWB
 (approx. 4500-7000k)

- Flash
 (approx. 5000-5500k)

- Daylight
 (approx. 5000-6000k)

- Cloudy/Overcast
 (approx. 6000-8000k)

- Shade
 (approx. 8000-10000k)

Light that emanates from the sun is essentially colorless, or neutral. But it soon gets scattered and refracted while passing through the atmosphere, which often causes the light to reach us with a color cast. In general, our eyesight adapts to the varied colors of light as our minds balance these differences. However, we can notice the color of light, sometimes referred to as temperature, particularly when the cast is quite strong, by observing the bluish color of distant mountain valleys (cool), or the amber glow that graces late afternoons (warm).

Light from an artificial source, such as a lamp or bulb, is rarely neutral in color. It might be deficient in blue, or have a strong color cast of its own. If photographing under artificial light, you must balance for an accurate or "true" color rendition in the image.

This color characteristic of light has an impact on photographs in two interrelated ways: One is the color of the light source itself; while the other is the way that source affects

Photos made in the shade generally exhibit a blue cast. This works well for most subjects in shade, but not for portraits. Counterbalancing the blue cast (left) with a warm white balance setting, such as Shade or Cloudy, will result in a more pleasing color rendition of the image (below).

Exposure Mode: *Aperture Priority*
Aperture: *f/8.0*
Shutter Speed: *1/80 second*
ISO: *320*
Metering: *Center-weighted Averaging*
White Balance: *Daylight*

the objects in the scene. In a digital camera, that relationship is handled via color temperature controls, also known as white balance.

Color temperature is determined by a scientific method of light classification in which the colors of red and yellow light have lower color temperatures than blue light. This may seem counter-intuitive, as we usually relate warmth to colors such as red and yellow.

In this system, the color of light at noon on a sunny day is approximately 5400 degrees Kelvin (or K, the scale used by this method). This is what most digital cameras call Daylight white balance. Overcast sky and certain atmospheric effects that alter the light to create a blue cast will be measured as about 8000K. The amber color of the sky as the sun begins to set is about 3200 K. And while our eyesight interprets the resulting color casts in most scenes to look normal (without much of a cast), our digital cameras do not—at least not without adjustments. That is where white balance comes in.

Exposure Mode: *Aperture Priority*
Aperture: *f/8.0*
Shutter Speed: *1/80 second*
ISO: *320*
Metering: *Center-weighted Averaging*
White Balance: *Shade*

Exposure Mode: *Manual*
Aperture: *f/2.8*
Shutter Speed: *1/30 second*
ISO: *800 (high ISO because not flash allowed in church)*
Metering: *Center-weighted Averaging*
White Balance: *AWB*

Exposure Mode: *Manual*
Aperture: *f/2.8*
Shutter Speed: *1/30 second*
ISO: *800*
Metering: *Center-weighted Averaging*
White Balance: *Tungsten*

The white balance control helps you record images without an unwanted color cast. It consists of several preset adjustments (see table on page 64), and is usually controlled from within the camera's menu system, or from a button on the camera's body. For example, setting the white balance for Shade would neutralize, or counterbalance, a blue cast by adding yellow/amber during processing. Or, to counterbalance a warm color cast, a white balance setting of Tungsten directs the processor to add blue.

When shooting pictures outdoors, I don't worry too much about balancing color because the emotional content of the scene is more important to me than getting color neutralized and precisely accurate. The easiest course is to set the white balance on Daylight, and then let the camera determine the color cast of the image. Setting the white balance on AWB (Auto) when working in natural light usually results in a fairly neutral color balance, but might also neutralize the emotional impact of the color at hand. Set-

ting it on Daylight usually delivers what you see. Indoors I am more mindful of the often poor results when using a Daylight WB; that's when I rely on the AWB setting or, if I need to be more specific (such as in an arena), on Tungsten or Fluorescent settings. (If shooting in RAW format, the white balance can be adjusted with software during RAW processing.)

Though AWB is often effective for interior scenes, those lit with tungsten or other types of filament lamps may sometimes have too much yellow, something the eye does not normally interpret but which the sensor will quite likely record (opposite page, far left).

You can counterbalance the warm (yellow/orange) color cast by setting the white balance to Tungsten (opposite page, right).

You can also work with color casts for creative, rather than corrective, purposes. Adding warmth can enhance a subject or make the photo appear as if it was made at a different time of day. It is a matter of individual taste as to which white balance setting works best for each shot. The plant in the more neutral version records closer to how it actually looked to my eye (below, left), but I prefer a warmer rendition for this subject (below, right).

Exposure Mode: *Manual*
Aperture: *f/11*
Shutter Speed: *1/250 second*
ISO: *100*
Metering: *Center-weighted Averaging*
White Balance: *Daylight*

Exposure Mode: *Manual*
Aperture: *f/11*
Shutter Speed: *1/250 second*
ISO: *100*
Metering: *Center-weighted Averaging*
White Balance: *Cloudy*

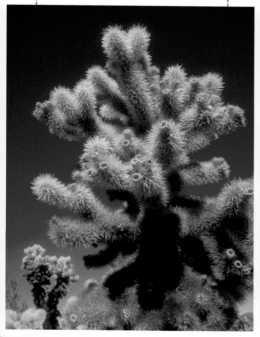

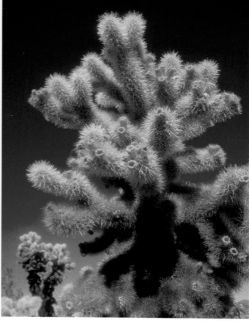

2.6 Using Scene Contrast

Analyzing Light to Make the Most Effective Photo:

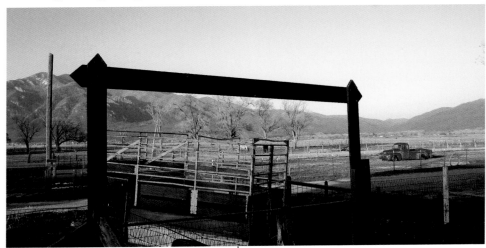

Exposure Mode: *Aperture Priority*
Aperture: *f/7*
Shutter Speed: *1/160 second*
ISO: *100*
Metering: *Center-weighted Averaging, read from bright sky, exposure locked and recomposed*
White Balance: *Daylight*

The light in a scene could be bright, dim, dappled, or diffuse, helping to create an atmosphere or ambiance that you might want to capture. But emotion and subjectivity mean little to your camera. To the sensor, the crucial matter in making good exposures is the degree of difference between the brightest and darkest areas in the scene. That objective difference is the scene's contrast. The way in which it is handled will determine how well the scene will be rendered.

Contrast can be measured through the use of the camera's light meter. Used correctly, the meter allows you to make informed decisions about how to make the best exposure. Therein lies the difference between the human and photographic eyes. When you work with a camera, you begin to analyze light—not for its own sake, but to insure the best way to read it with the meter and make an exposure that encompasses as many light values as possible between the brightest and darkest.

One reason you see scenes differently than the camera is because your brain interprets a continual stream of information as your eyes scan the scene, adapting to degrees of light

and dark, while the camera exposure is a fixed moment when only a set amount of light gets through. In the ranch photo to the left, your eyes scan the entire scene and make adjustments enabling you to see detail in the foreground shadows and in the rough planking of the fence. You must consider the contrast when determining how to photograph a scene, realizing that when contrast is high, you probably cannot record the scene as you perceive it. By reading the bright sky in this photo with the light meter, the exposure has been set so that details in the brighter areas will be recorded (see pages 88–91 for more about center-weighted averaging metering). Consequently, the shadows will register as much darker than our eyes see them, because scene contrast is so high.

In the crowd scene (right, above), my intention was to have the rush of commuters in the shadows, which is partly interpretive and partly dictated by the backlighting (see page 60) that includes bright highlight areas on the sidewalk and in the upper portions of the building. Metering for the darkened people in the crowd would have produced a poor exposure (very bright, overexposed highlight) and would not have conveyed the mood I felt for that image.

When you see with camera vision, you gain an understanding of how the scene before you will look as a photograph. This process is called previsualization—a fancy word that

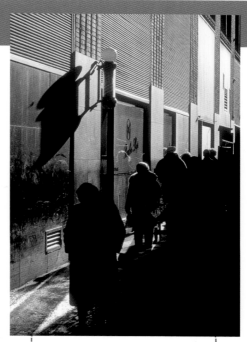

Exposure Mode: *Aperture Priority*
Aperture: *f/16*
Shutter Speed*: 1/250second*
ISO: *100*
Metering: *Center-weighted Averaging, read from upper left portion of building, exposure locked and recomposed*
White Balance: *Daylight*

means that you know there is a difference between how your eyes see and how the sensor records, and you understand how to exploit that difference to make the best exposure possible. This knowledge will guide your exposure techniques, your expectations, and even, to an extent, your composition.

2.7 Low-Contrast Scenes

Tools:

- Manual Exposure Mode
- Aperture Priority or Shutter Priority Exposure Modes
- Multi-segment (Evaluative/Matrix) Metering
- In-camera Saturation or Contrast Enhancement, or Processing Steps in Computer

Flat light might seem to be boring and un-inspiring, but in fact is a wonderful lighting condition under which to make images. It is defined as having little or no contrast in terms of brightness, although contrast through color variation can be rich.

You can judge flat light by examining exposure settings in your camera's viewfinder (or LCD). Activate your meter by lightly pressing the shutter release and point the camera at different portions of the scene. If the readings do not change to any noticeable degree, you will know that the contrast is low. Once you have made a reading, you can easily

Exposure Mode: *Aperture Priority*
Aperture: *f/5.6*
Shutter Speed: *1/30 second*
ISO: *100*
Metering: *Center-weighted Averagin*
White Balance: *Daylight*
Image-Processing with Software

After exposure of this flatly-lit scene, I lightened the water and retouched the wave foam to bring more contrast into the area. This bit of custom processing gave a nice spark of life to an otherwise dull-looking image..

Exposure Mode: *Shutter Priority*

Aperture: *f/7.1*

Shutter Speed: *1/320 second*

ISO: *160*

Metering: *Centered-weighted Averaging*

White Balance: *Shade*

Exposure Compensation: *−0.3EV*

Sharpening: *+1 in-camera setting (which I often use for graphics)*

Image-Processing with Software

I enjoy photographing old commercial signs, as I know they will usually be gone the next time I travel through that area of the country. This one sat in the shade as I walked around a small town one morning. Since I was en route elsewhere and couldn't wait for the right light, I made the shot anyway (top), knowing I could enhance it later with a slight overall addition of contrast and brightness (bottom).

switch the camera to Manual exposure mode and keep the reading constant, or choose a desired image effect by using Aperture Priority or Shutter Priority exposure modes. Flat light can be read by any metering pattern, but multi-segment (evaluative/matrix) does quite well under most conditions.

Just because you shoot in low contrast light doesn't mean the final image need be dull. Feel free to look in the camera's menu system to set a mode for recording enhanced saturation or higher contrast, or process the image to your liking later with computer software. Low contrast light allows for perhaps more processing freedom than any other lighting condition.

In some cases, the metering pattern you use may overexpose a dark, flatly lit scene to a certain extent. But this particular challenge is easily remedied in image-processing, where you can make successful adjustments to raise brightness and/or contrast.

You will often run across a scene or subject that would make an interesting photo except that, unfortunately, the light is not bright enough (or "right" enough), so you pass on taking the photo. But my advice is: Don't do it—make the shot. You can often maximize the existing light easily enough by adding contrast and color saturation, either through in-camera tools or with image-processing software.

Flat Light: Before and After

To give you a sense of what I mean by using flat lighting to serve as a foundation for creative work, here are before and after shots of a scene photographed under overcast light. There was virtually no difference in exposure throughout this area, so I set the camera on Manual exposure mode at a narrow aperture and just took the shot. Later I processed the image to bring out all the color and contrast I desired. The lack of contrast made it much easier to build the image from the start, rather than have the camera exposure and settings create boundaries.

Exposure Mode: *Manual*

Aperture: *f/16*

Shutter Speed: *1/45 second (in-lens stabilization)*

ISO: *800 (necessary to get an image-stabilized, handholdable shutter speed)*

Metering: *Multi-segment (Evaluative/Matrix)*

White Balance: *Daylight*

Image-Processing:

Curves control to enhance contrast.

Hue/Saturation applied to enhance blues and yellows; Burn tool on duplicate Layer to create contrast between plants, rocks, and ground.

2.8 The Beauty of Reflected Fill

Tools:

- Multi-segment (Evaluative/Matrix) or Spot Metering
- Aperture Priority or Shutter Priority Exposure Mode

Sometimes the most beautiful light is indirect, which means it reflects from other surfaces onto your subject or scene. This type of "reflected fill" occurs in many situations. For instance, keep an eye out for subjects that sit on the shady side of a street when glass buildings on the opposite side are reflecting sunlight, or those under a forest canopy as the light from a stream or lake bounces into the shade, or even objects within deep valleys where the rays of the sun are reflected from light-colored canyon walls.

You can add reflected fill yourself through the use of reflective discs (commercial equipment often used by portrait photographers), a white piece of cardboard, or even a parked car or truck that catches the light and kicks it into your scene. Reflected light has an edge and a glow, but does not create harsh contrast that would be present should the subject be lit directly by the sun. Look for its special quality as you shoot.

Exposure Mode: *Aperture Priority*
Aperture: *f/16*
Shutter Speed: *1/60 second*
ISO: *100*
Metering: *Multi-segment (Evaluative/Matrix)*
White Balance: *Daylight*

There's a quality of light to reflected fill that is unmatched by any other source and situation. It's as if you are in a dark studio and have lit your subject with an immense, soft lightbox. This front door of an abandoned dance hall above shimmers with light thrown by a bright white sidewalk that was right beneath my feet as I shot.

Exposure Mode: *Shutter Priority*

Aperture: *f/8*

Shutter Speed: *1/400 second*

ISO: *800 (no flash allowed inside church)*

Metering: *Spot, read from face of statue*

White Balance: *AWB*

This statue sat on a large beige shelf inside a window alcove in a church. Although strongly backlit, the shelf worked as a reflective surface to fill light into the face area. While the window panes are slightly overexposed, the brightness serves as a halo around the figurine.

The brilliant color of this graffiti does not result from direct sunlight hitting it, but from the light reflected from a building across the lot in late afternoon. Direct light might have washed out the color and caused harsh contrast, but reflected fill turned out to be the perfect light in which to make this photo.

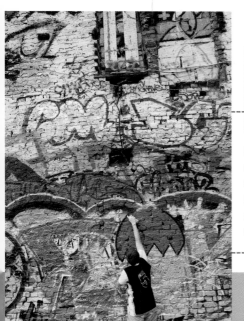

Exposure Mode: *Shutter Priority*

Aperture: *f/4*

Shutter Speed: *1/500 second*

ISO: *250*

Metering: *Multi-segment (Evaluative/Matrix)*

White Balance: *Daylight*

2.9 Light as Seen

Light as Recorded

Tools:

- Different Metering Patterns
 Multi-segment (Evaluative/Matrix)
 Center-weighted Averaging
 Spot
- Exposure Lock
- Exposure Compensation
- In-camera Picture Styles
 (e.g. Monochrome)
- In-camera Filters

Dealing with light produces both objective and subjective visual experiences in digital photography. The objective, or more scientific, aspects consist of measuring the light and understanding the tools for manipulating it. There is a difference between how you perceive light and how the camera records it, so you must recognize the limits of your digital camera's sensor as well as learn the various methods for gathering information about the existing light. You should also realize how various image effects are achieved through changes in aperture and shutter speed settings.

The subjective, more artistic qualities, have to do with the way you see and remember the light in the scene, and most importantly, how that light is reproduced in your images.

There's a balance between the two, and the choice facing photographers is how to apply the objective portion of the equation to serve the interpretive photograph.

The top image to the right is a tonal exercise, like practicing scales on a piano, because it illustrates a full set of brightness values, ranging from the black shadows within the image, to the middle gray of the fence, and to the white, slightly textured wall below the chimneys. I recommend that you look for such scenes to record as you begin to learn about light. You will discover, for instance, that the white wall is actually a half tone darker than the chimney above it, and the fence railing is a half tone lighter than the roof shingles. This objective exposure displays the full scale of tonal values available in the original scene, and appreciating its full spectrum is subjectively pleasing as well.

The bottom photo to the right is not focused because the camera moved during the exposure. There is no detail in the shadows, and one is left with a disconcerted feeling—but that's the idea of the shot. This is an entirely subjective take. Those who rigidly follow histograms as a guide to proper exposure would simply toss this out. But for me, this is a favorite shot of the Strip in Las Vegas, expressing perfectly my feeling about being there.

Exposure Mode: *Aperture Priority*
Aperture: *f/16*
Shutter Speed: *1/125 second*
ISO: *100*
Metering: *Spot, read from brightest wall, exposure locked and recomposed*
White Balance: *Daylight*
Exposure Compensation: *+1EV*

Exposure Mode: *Program*
Aperture: *f/5.6*
Shutter Speed: *1/8 second*
ISO: *800*
Metering: *Multi-segment (Evaluative/Matrix)*
White Balance: *AWB*

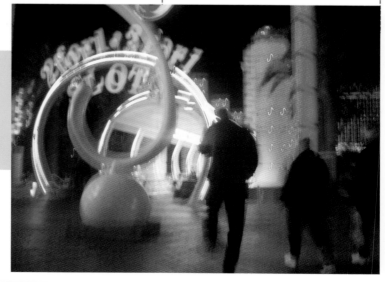

did u know?

For quick, "from the hip" shots (meaning handheld photos not viewed through the finder), often set Program exposure mode and rely on the camera's multi-segment metering pattern and Auto ISO.

All digital photographs are recorded in a color space that is a combination of red, green, and blue (RGB). This does not mean that you are hindered in any way from making black-and-white images from them—in fact, you will find that digital photography makes black and white quite accessible. Digital cameras allow you to make black and white images in-camera with Monochrome shooting modes, or you can use software to process recorded images as black-and-white pictures in the computer.

Momochrome pictures depict subjects that rely on form, texture, and the interplay of light and shadow, but you need not expose differently than normal. The photo to the right was exposed by metering on the bright cliffs in the lower left of the scene, and then locking exposure and reframing. This caused the shadows in the gorge to become deep and dark, leaving the reflective ribbon of the Rio Grande to show its flow.

The window scene to the rar right is about reflections and how light reshapes and defines form. The angles of the panes in the separate windows reflect different brightness values, with the red neon sign present only as a reflection that is warped by the shape of the glass. If spot metering had been used to read the bright portion of the window to the right, the rest of the scene would have been

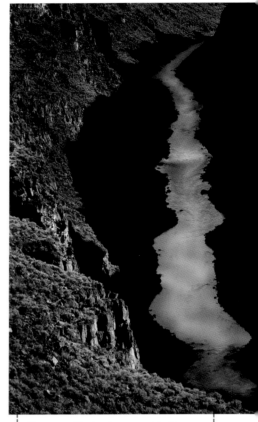

Exposure Mode: *Aperture Priority*
Aperture: *f/16*
Shutter Speed: *1/125 second*
ISO: *200*
Metering: *Center-weighted Averaging*
White Balance: *Daylight*
Monochrome Picture Style
In-camera Yellow Filter

Exposure Mode: *Aperture Priority*

Aperture: *f/8*

Shutter Speed: *1/60 second*

ISO: *100*

Metering: *Center-weighted Averaging*

White Balance: *Daylight*

When you look at a potential photograph, you should consider the light and how you can best capture it to express your vision. At the same time, you should make an exposure that registers as much light information as you can.

quite dark. However, the exposure was made using a center-weighted averaging to read those bright panes. This metering pattern incorporates the light values of both the angled window and the red neon reflection, and averages them, thus properly placing them within the full range of exposure from light to dark. Selecting a pattern for metering, then choosing where in the scene to read the light, are the kinds of judgments you will make to record a scene the way you see and envision it. (See pages 84–95 for more about metering patterns.)

It is usually important to record all of the light information you can, but it may not always be as important to show every bit of the information that you see. For example, the details of what's in the barrel or in the roof rafters are not important in the waterfront photo below. In fact, contrast is what's important, with disparate subjects and forms divided by deep shadow areas. It is a catalog of shapes and the way in which deep shadow defines them. Exposure is an integral part of the interpretation of this scene, and serves the end purpose of what the image addresses.

Though the eye of the viewer is often guided by the predominance of form or motion within a frame, we as photographers wait patiently for the interplay of light and shadow to reveal itself, as in the skyline scene at right. We know that "just the right light" makes a photo noteworthy. We manipulate lens, camera, and even software, to create a particular lighting look, to catch the eye or insure that our subject is clear and noticeable within the frame. The craft of exposure is knowing when the light is right, and then capturing its essence to produce the image we desire.

Exposure Mode: *Aperture Priority*
Aperture: *f/16*
Shutter Speed: *1/125 second*
ISO: *200*
Metering: *Spot, read from orange forklift, exposure locked and recomposed*
White Balance: *Daylight*

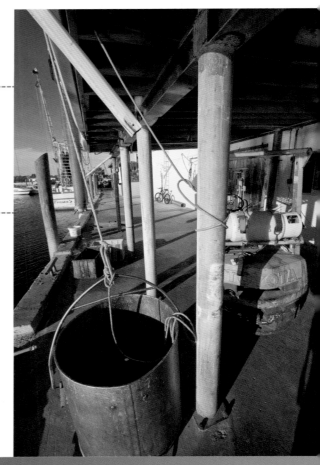

Exposure Mode: *Shutter Priority*

Aperture: *f/8*

Shutter Speed: *1/1000 second*

ISO: *400*

Metering: *Spot, read from Chrysler Building (center), exposure locked and recomposed*

White Balance: *Daylight*

Metering and Processing

Your in-camera metering system works with sophisticated technology and programming designed to read and then translate light to get the best exposure possible. This system is usually quite effective, but certain challenging lighting conditions will often require your considered input to make the best reading. Knowing when to rely solely on automation, and when to override the built-in system using other metering patterns, modes, and light reading techniques is key to making the best exposure under every lighting condition.

One major benefit of digital photography is that it allows photographers to record a full range of light, and to approach every frame with the idea of applying custom processing and printing. RAW file format, and the accompanying processing capabilities it affords, opens the door to newfound creative and corrective measures. Recent technology also allows for overcoming past problems with high contrast and highlight exposure control, including HDR (high dynamic range) and tone curve compensation techniques.

3

3.1 Multi-Segment Metering

When to Use It, and When Not to

Tools:

- Multi-Segment (Evaluative/Matrix) Metering
- Center-Weighted Averaging Metering
- Tone Curve Compensation

Multi-segment metering is known by various names, depending on the brand of equipment you use, with evaluative, matrix, pattern, or multi-pattern among the most common. Whatever the name, this type of metering takes light readings from numerous areas around the frame, calculates these various brightness values, and adds other information to the mix, such as lens focal length. It then refers the calculation to a reference table in the camera's memory and determines an exposure solution to the lighting condition. This is all controlled by the camera's microprocessor, and relies on stored information (a database) that includes look-up tables and thousands of exposure combinations.

Your camera's multi-segment system will deliver good exposures 80% of the time—if 80% of your shots are made without much contrast and if the subjects are well lit by the sun coming from behind you as you photograph. In that case, select multi-segment metering, pick the aperture or shutter speed that matches the image effect you want, and frame the scene. It also is quite handy for standard flash pictures when you use the flash and Program exposure mode.

While this pattern is popular and easy to use because it relies on the camera's computer to determine exposure, it does not adequately address every lighting situation. Those who enjoy having more control over their work will opt to use the other two patterns (spot and center-weighted averaging), which offer the photographer, not the camera, finer command of exposure control.

In terms of lighting, note the tricky pattern of highlight and shadow in the photo to the right, above. Though a fairly complex scene,

the sun is coming from behind me. I made this exposure specifically to test the meter's accuracy. I selected Program exposure mode and set multi-segment metering (in this case, Canon's Evaluative), and made the shot as framed. The exposure system nailed it, with texture in the highlight and information in the shadows. It is important to test your camera to see how well your multi-segment meter can handle such scenes—not all metering systems are the same!

I have been testing cameras for many years and have found that, in general, multi-segment metering tends to overexpose in high contrast situations. The programming is intended to capture as wide a range of exposure values as possible, and while this is

Exposure Mode: *Program*
Aperture: *f/11*
Shutter Speed: *1/640 second*
ISO: *200*
Metering: *Multi-segment (Evaluative/Matrix)*
White Balance: *Daylight*

usually a good thing, it tends to overexpose bright highlights, probably because it takes too much of the darker areas (shadows) into consideration. Advances in built-in tone curve compensation might yet solve this problem (a function that automatically balances shadow and highlight, see page 100). That's why spot and center-weighted averaging metering patterns are still useful functions on modern D-SLRs.

This urban scene is a perfect setup for multi-segment metering. The sun coming from the left is bascially over-the-shoulder light that produces broad lighting across the scene without creating excessive contrast. For lighting conditions like this, set your camera to multi-segment metering, pick the exposure mode for the image effect you desire (here Aperture Priority), then frame and shoot.

Exposure Mode: *Aperture Priority*

Aperture: *f/11*

Shutter Speed: *1/60 second*

ISO: *100*

Metering: *Multi-segment (Evaluative/Matrix)*

White Balance: *Daylight*

Look at the two photos of the yellow flower on the opposite page. The top image was made using multi-segment metering. This shot does a good job of revealing shadow detail, but it pushes the highlights a bit too far so they are too bright. This might be recoverable in the computer using software, but it still creates an overexposure situation.

I selected center-weighted averaging to shoot the photo at the bottom of the page. I locked the exposure on the bright area of the flower, which gave me an exposure that controlled highlights and, in fact, recorded the scene just as I had envisioned it.

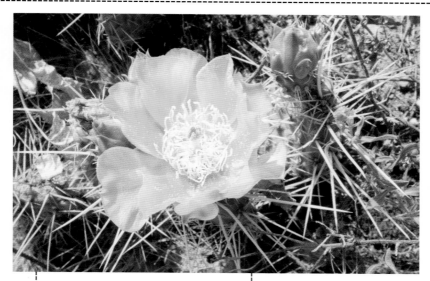

Exposure Mode: *Aperture Priority*
Aperture: *f/16*
Shutter Speed: *1/60 second*
ISO: *200*
Metering: *Multi-segment (Evaluative/Matrix)*
White Balance: *Daylight*

Exposure Mode: *Aperture Priority*
Aperture: *f/22*
Shutter Speed: *1/25 second*
ISO: *200*
Metering: *Center-weighted Averaging, read from the center of flower*
White Balance: *Daylight*

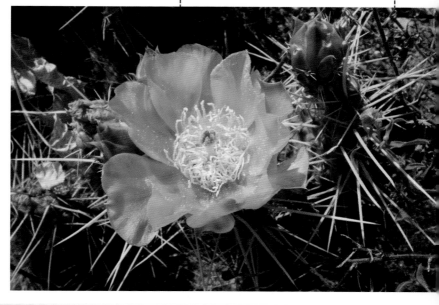

3.2 Biasing Toward the Highlight

Center-Weighted Averaging Metering

Tools:

- Center-Weighted Averaging Metering
- Autoexposure Lock (AEL)

When using center-weighted averaging metering (CWA), the light is read from all parts of the viewfinder. However, about 70% of the reading is calculated from the center of the frame, while the remaining 30% comes from areas toward the edges of the frame. It is called averaging because the camera takes the various brightness levels and averages them to what is called a "middle gray" exposure reading.

The key to CWA is to read the correct area to produce the most effective exposure. Because you choose center-weighted to work with scenes that possess fairly high contrast, such as a landscapes with a bright sky and darker ground, or sunset scenes with deep shadows, it is important to take a reading that incorporates the bright area in the center of the frame, regardless of your final composition.

In most cases you want to control overexposure, so you should always include the brighter areas within the frame when you make readings. You do not need to have the bright area cover the center metering zone entirely (that's how spot metering makes an exposure reading), but you should be sure to include that bright area toward the center of the frame. Remember, overexposure is one miscue you want to avoid—it is preferable to capture highlights properly, even if it means losing detail in the shadows. In many cases, that lost shadow area is recoverable with image-processing software. That's why center-weighted averaging is my most used exposure pattern.

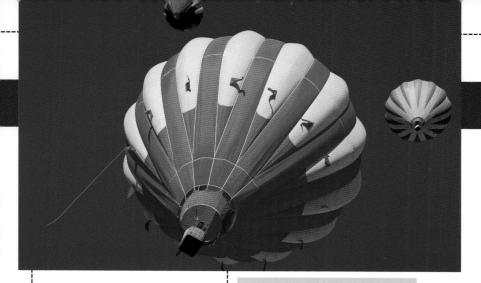

Exposure Mode: *Shutter Priority*
Aperture: *f/6.3*
Shutter Speed: *1/500 second*
ISO: *200*
Metering: *Center-weighted Averaging*
White Balance: *Daylight*

This photo gives a good illustration of the way the CWA pattern covers a scene in your viewfinder, with the center balloon representing where the majority of the reading is made.

You do not want dark areas within a landscape to affect the exposure in such a way that the brighter areas become washed out. To retain shadow in the rock formation, I aimed the camera so the sky to the right was in the center of my view-finder, but still included the cliff face within the edge of the frame. I then locked exposure and recomposed to bring more of the rocks into the frame. This produced proper expo-sure of both sky and rocks.

Exposure Mode: *Aperture Priority*
Aperture: *f/16*
Shutter Speed: *1/125 second*
ISO: *100*
Metering: *Center-weighted Averaging, exposure locked and recomposed*
White Balance: *Daylight*

3

Basing your exposure on a bright area of the scene is a technique known as "biasing toward the highlight," a common practice among slide film photographers. If working in Manual exposure mode, change the aperture and/or shutter speed until the exposure indicator in the viewfinder is at the center of the +/− exposure graph. If recording in an autoexposure mode (Auto, Program, Aperture Priority, Shutter Priority), make a reading and then lock it using the automatic exposure lock (AEL) button if you have to recompose.

Most of the time, CWA is best used when there is a lot of contrast in the scene (including deep shadows), when the subject is backlit, or when highly directional light (coming from the sides) has a strong influence.

Follow the light and read from the area that includes the brighter portions of the frame when working with CWA. Here the camera was raised toward the brighter areas in the upper portion of the frame, exposure was locked using the AEL button, and then the shot was recomposed as you see here.

Exposure Mode: *Shutter Priority*
Aperture: *f/2.8*
Shutter Speed: *1/40 second*
ISO: *400*
Metering: *Center-weighted Averaging*
White Balance: *Daylight*
Autoexposure Lock and recompose

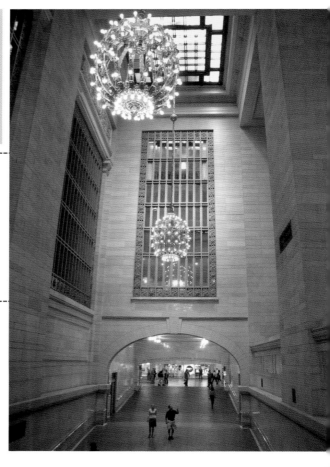

Exposure Mode: *Aperture Priority*
Aperture: *f/8*
Shutter Speed: *1/1000 second*
ISO: *200*
Metering: *Center-weighted Averaging*
White Balance: *Daylight*
Autoexposure Lock and recompose

This late afternoon street scene has very deep shadows and very bright walls. I saw the nearly black shadows as an important part of the composition, so I swung the camera to the left, locked the CWA reading from the brighter areas, then recomposed before recording.

Exposure Mode: *Manual*
Aperture: *f/8*
Shutter Speed: *1/160 second*
ISO: *400*
Metering: *Center-weighted Averaging*
White Balance: *Daylight*

For this portrait with light coming through a window to camera right of Emma, I set CWA and read from the brighter side of her face. Using Manual exposure mode, I then recomposed. Once exposure is set in Manual mode, it will not change, so you don't need to make new readings when shooting portraits using fixed light positions.

3.3 Spot Metering

The Selective Method for Reading Light

Tools:

- Spot Metering
- Autoexposure Lock
- Exposure Compensation Control
- Custom Function (if available to control diameter of spot reading area in viewfinder)

As with center-weighted averaging, spot metering also regards whatever it is reading as middle gray. However, the spot method takes its reading from a specific area within the frame, rather than from the overall frame. That specific spot area can be a small circular portion at the center of the viewfinder (in some cameras you can control the diameter

The area used to spot meter is a small portion in the center of the viewfinder frame—as little as one percent. Aim the camera so the center of the frame points at the light value or color you want to read (in this case, the sky). You will usually have to lock that exposure so you can move the camera to reframe your shot.

did u know?

The easiest way to saturate a bright color in a scene, and to insure dark shadows as a vivid contrast, is to spot read from the desired color and lock the exposure. The spot meter reads the color as middle gray, thus the shadows become relatively darker than normal. If using a multi-segment pattern, the metering would tend to open exposure in the shadows, greatly reducing the desired effect.

Exposure Mode: *Aperture Priority*
Aperture: *f/11*
Shutter Speed: *1/125 second*
ISO: *100*
Metering: *Spot, read from yellow hull in background*
White Balance: *Daylight*

of that spot), or from a specific focusing target that you select. Aim the camera so the spot metering indication sits right on top of the area you want to read. With spot metering, you often have to compensate exposure somewhat, though you may be able to use it as a final exposure if the spot area is a vivid color, and not bright white.

Spot metering is a very controlled technique, and therefore is probably the most accurate way to measure light, given you have the time to make the reading and the experience to know how to use the information. It is especially helpful in digital photography because you can always read the important highlight information in the scene and compensate accordingly.

To take the best advantage of spot metering, use it to:

- Insure that you have the correct highlight value in scenes that contain a lot of contrast.

- Pick out select portions of the scene for exposure readings.

- Shoot in snow or bright light when a white dominant framing exists.

- Saturate a color such as red, orange, or yellow. Produce silhouettes within the scene.

One of the best ways to capture the beautiful light of the setting sun on a shot like this is to point the spot meter at the brightest area of the building and lock the exposure.

When light tones dominate a scene, such as the storefront in the image below, the meter will tend to "pull" the highlight toward middle gray (darker). This not only can result in a gray rendition of a white subject, but also "push down" the other light values in the scene and make them darker than you would like. The easiest way to solve this dilemma is to meter a bright area in the scene (in this case, the white wall) using spot metering, and add +1 exposure compensation (designated as +1EV, or exposure value). If the white is highly reflective (such as snow on a bright day), you may have to add 1.5EV.

Exposure Mode: *Manual*
Aperture: *f/5.6*
Shutter Speed: *1/500 second*
ISO: *100*
Metering: *Spot, read from bright area of building, exposure locked and recomposed*
White Balance: *Daylight*

Exposure Mode: *Aperture Priority*
Aperture: *f/16*
Shutter Speed: *1/250 second*
ISO: *100*
Metering: *Spot, read from white wall, exposure locked and recomposed*
White Balance: *AWB*
Exposure Compensation: *+1EV*

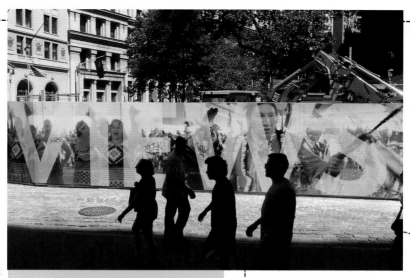

If you plan to silhouette part of a scene, make an exposure reading from the brightest portion within the frame using spot metering, then lock exposure and shoot.

Exposure Mode: *Aperture Priority*
Aperture: *f/11*
Shutter Speed: *1/350 second*
ISO: *200*
Metering: *Spot, read from billboard in background, exposure locked and recomposed*
White Balance: *Daylight*

Exposure Mode: *Aperture Priority*
Aperture: *f/16*
Shutter Speed: *1/250 second*
ISO: *400*
Metering: *Spot, read from bright foreground snow, exposure locked and recomposed*
White Balance: *Daylight*
Exposure Compensation: *+1.5EV*

Snow photos in bright light can easily become poorly exposed. Spot metering helps you expose such scenes properly. It is critical to take control of where you place the spot, aiming at a highlight value. In the snowscape to the left, the spot reading was made off the bright snow in the foreground, and exposure compensation was set to +1.5EV.

3.4 Exposure Compensation

When Metering Needs Some Help

Tools:

- Exposure Compensation
- All Metering Patterns

With the impressive automatic exposure systems found in today's digital cameras, selecting the proper metering choice for specific situations will usually produce a good image. These different metering modes should be applied when appropriate: Multi-segment when the light falls from behind you and illuminates the scene fairly evenly; center-weighted averaging when there is high contrast or when a bright area is dominant toward one of the edges of your frame; spot when a bright area is white or when you want to saturate a specific color.

But there are times when you will want to tweak the exposure by adding or subtracting light that has been set by the metering system. This type of override is known as exposure compensation, and is expressed in terms of exposure values (EVs). The control is usually found as a button or dial in the camera, with a plus/minus scale like the one that denotes the reading for Manual exposure.

Use compensation in the following ways with the matched metering patterns:

Multi-segment: You can try minus exposure compensation in high contrast scenes, although it is usually better to use CWA or spot to handle high contrast. When there is a great deal of contrast, multi-segment tends to bridge the gap between light and dark, bringing too much of the shadow information, thus overexposing the highlights.

Center-weighted Averaging (CWA): In general, exposure compensation (plus or minus) is only used when you need to tweak exposure due to a clipped histogram (see page 38) or the appearance of highlight/shadow warning blinkies (see page 34) on the playback image. Done correctly, CWA often does not require compensation because you are following the light and controlling the highlights accordingly (see pages 88–91).

Spot: If you meter a bright white area in the scene, it will record as middle gray. You can boost the brightness of that value by adding plus exposure compensation.

Exposure Mode: *Shutter Priority*

Aperture: *f/5*

Shutter Speed: *1/2000 second*

ISO: *200*

Metering: *Spot, read from white wall, exposure locked and recomposed*

White Balance: *Daylight*

Exposure Compensation: *+1EV (moves shutter speed from 1/4000 second)*

What may seem a tough task for any metering pattern can often be corrected without much pain once you have mastered exposure compensation techniques. The easiest way to deal with a high-contrast scene, like the one in the photo above, is to aim the spot meter at the white portion of the wall and use +1 exposure compensation in any auto-exposure mode. The dominance of white in the scene would otherwise record as middle gray—probably not very attractive for this photo—while the rest of the color and tones would go darker. This would make all the detail in the shadow area become a featureless dark tone. Minus exposure compensation is not as common in digital photography as plus compensation, primarily because the image can usually be adjusted to match the dark mood later in the computer with image-processing software, even if the picture is slightly overexposed (as long as highlights maintain texture in the original exposure).

There are, however, times to use minus compensation, such as when trying to capture an elusive rainbow like the one below. Because the sky is dark behind the lighter rainbow, the metering system will tend to add more exposure than necessary to compensate, thus making the rainbow too light and less dramatic. Set minus exposure compensation in any exposure mode to help capture the full brilliance of a rainbow's spectrum. The same could apply to sunset shots when you want to enhance the colors in the sky.

Exposure Mode: *Shutter Priority*
Aperture: *f/4.4*
Shutter Speed: *1/150 second*
ISO: *200*
Metering: *Center-weighted Averaging (as framed)*
White Balance: *Daylight*
Exposure Compensation: *−1EV*

The Camera's Meter and Exposure Compensation

Imagine you are photographing in deep shade where the ambiance is moody. You make an exposure and the resultant picture looks too light, losing all its drama. What the meter has done is to place the dominant dark tones in the middle of the sensor's recording range, making the scene lighter than you might like. The solution is to take away exposure by using a minus exposure compensation, perhaps −1EV. More often than not, difficulty in metering the scene for just the right exposure occurs in high-contrast lighting conditions rather than scenes that are predominantly bright or dark.

A late spring snow covered this pond (right). The challenge was to properly expose for the snow without making it too gray, and to record detail in the much darker water. I took a reading from the snow (highlight) and then added +1.5EV to the exposure. I didn't care if there was very little texture in the snow, and the plus compensation brought up the forms and colors found in the water, which other-wise would have been too dark.

Exposure Mode: *Aperture Priority*
Aperture: *f/11*
Shutter Speed: *1/125 second*
ISO: *400*
Metering: *Center-weighted Averaging, read from snow, exposure locked and recomposed*
White Balance: *Daylight*
Exposure Compensation: *+1.5EV*

3.5 Tone Curve Adjustment

A Tool to Refine Contrast in Your Exposures

Tools:

- Tone Curve Compensation (in-camera)

Long the province of image-editing soft-ware, the ability to adjust tone curve has now been incorporated within the camera on most recent D-SLRs. This menu choice means that you can alter the relationship of bright to dark areas—contrast—as part of the exposure choices you make while shooting or immediately after. And, with some models, you can even choose to have the camera make a bracketed set of contrast changes.

Different brands of cameras may call this tool by different names. You may encounter names like D-Lighting, DRO (dynamic range optimization), and similar. But whatever camera you use, what originally was a complex operation using such software tools as Highlight/Shadow or Curves Adjustment Layers in computer imaging programs can now be quickly used in the field, and becomes a good choice for overcoming excessive scene contrast. Tone curve adjustments differ from contrast changes in that they alter the actual relationship of highlight to shadow—usually by opening up or making the shadows lighter—rather than making the entire scene higher or lower in contrast.

When using tone curve controls, you should consider the effect you want in the photograph. Opening the shadows is best in some cases; in others, that effect might take away from the mood of the shot. To the right are two images of the Flatiron Building in New York City. The exposure settings are the same, except the lower one has the tone curve tool turned on to lighten the darker areas. Which one is most effective?

Exposure Mode: *Aperture Priority*
Aperture: *f/8*
Shutter Speed: *1/1000 second*
ISO: *200*
Metering: *Multi-segment (Evaluative/Matrix)*
White Balance: *AWB*

This set of images was made with the same exposure settings but with a tone curve adjustment turned off (near right) and on (far right). Note the dramatic difference in shadow detail.

Exposure Mode: *Shutter Priority*
Aperture: *f/9*
Shutter Speed: *1/60 second*
ISO: *2500*
Metering: *Multi-segment (Evaluative/Matrix)*
White Balance: *Daylight*

Bracketing tone curve compensation allows you to make three photographs of the same scene, and then choose the reproduction that sets the right mood and reveals the details you desire. This requires you to only make one exposure: The in-camera processor then makes two more images, each with a different tone curve, as illustrated in this three-photo set. The scene with highest contrast (nearest right) is the tone curve as shot, while the scene with the most open range of tones (farthest right) has a +2 tone curve setting applied.

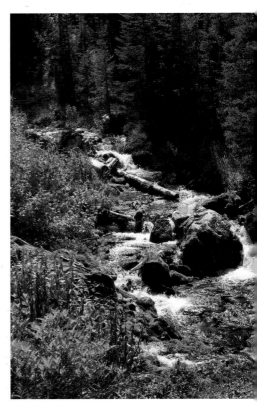

Aperture: *f/10*

Shutter Speed: *1/160 second*

ISO: *100*

Metering: *Center-weighted Averaging*

White Balance: *AWB*

Tone Curve Compensation: *Bracket set for normal, +1, and +2*

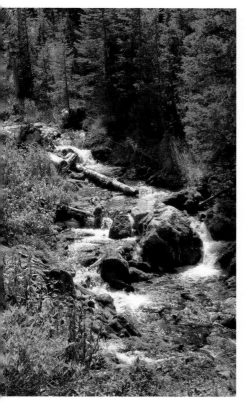

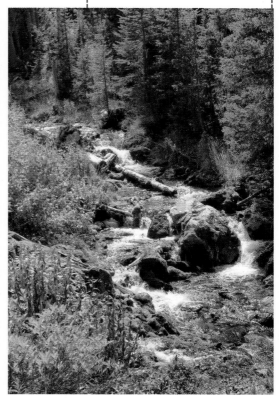

3.6 RAW Files

Get the Most When Processing Images

Tools:

- Raw Processing Programs, among them:

 Adobe Camera Raw (in Photoshop and Elements)

 Aperture

 Lightroom

 Bibble, and others

While the best way to make great photographs is to get the best exposure you can when you snap the shutter, the truth is that digital images possess some leeway to rectify exposure miscues and allow for corrections in the processing stage. This does not mean that you should be nonchalant about exposure. It is much more efficient to spend your time photographing, not fixing those photographs in a computer. But image-processing programs have become increasingly sophisticated in how they can help maximize your images and, if need be, fix problems that in the past might have caused you to toss out the image.

The best file format for processing is RAW, which contains more information than other formats, thus can withstand more adjustments. But you can also perform many processing corrections on JPEG images as well. You can very often fix color cast, exposure, and contrast problems. I will not go into extensive procedures here, or show a series of screen shots and step-by-step procedures. That's for another book and another day. My aim is to give you a hint at the potential afforded by image processing, and hopefully encourage you to explore it further.

Image processing sometimes can come to the rescue of an image that you've exposed poorly, or when you shoot under less than ideal lighting conditions. While you should always aim for good exposure, image processing can often help rectify these types of images, especially when you have recorded using RAW format. In the pictures to the right, overexposure has been handled by selective adjustments during processing in Adobe Camera Raw.

Exposure Mode: *Aperture Priority*
Aperture: *f/8*
Shutter Speed: *1/250*
ISO: *200*
Metering: *Multi-segment (Evaluative/Matrix)*
White Balance: *Daylight*

Some adjustments to the RAW file were made to enhance exposure, contrast, and saturation during processing (above) of this originally overexposed photo (left).

Exposure Mode: *Shutter Priority*
Aperture: *f/22*
Shutter Speed: *1/8 second*
ISO: *100*
Metering: *Multi-segment (Evaluative/Matrix)*
White Balance: *Daylight*
Panning during exposure

Not only can image-processing software help fix problems, but it can also allow you to play with variations on the photos you take. The two images above of the running horses illustrate such alternative views. Each was made from an original with different degrees of darkening at the top and bottom of the frame, and with slightly different color saturation. The changes were made in seconds in Adobe Camera Raw.

There are times when the natural light does not cooperate with your expectations, and the result is a rather drab scene (right, top). While that type of light may have a certain charm for some kinds of atmospheric photos or detail-oriented pictures, it doesn't help much for scenic images, unless you can brighten the mood with processing, as I did in the bottom photo to the right. RAW files usually afford more leeway for this type of processing.

Exposure Mode: *Program*
Aperture: *f/5*
Shutter Speed: *1/250 second*
ISO: *200*
Metering: *Multi-segment (Evaluative/Matrix)*
White Balance: *Daylight*

RAW processing included lightening overall image, adding a dose of saturation to the whole image, as well as extra saturation to green tree, and warming of white balance.

3.7 Super High Contrast Images

Bracketing for HDR without a Tripod

Tools:

- Shutter-Priority Exposure Mode
- Highlight Warning in Playback
- HDR Software (Photoshop, Photomatix Pro, etc.)

One challenge to this type of shooting is to make sure that each exposure has the same framing. You will not be able to properly blend the photos if the series of bracketed shots is not aligned. This is generally done by mounting the camera on a tripod. There are times, however, when you might not have a tripod with you, and that's when high-speed bracketing comes into play.

Remember that your eyes adapt to the bright and dark areas of a scene (see pages 68–69), while the camera exposure is a fixed moment when only a set amount of light is recorded. This means that you and the camera see light differently, and there are times when your camera's sensor cannot possibly capture a scene's wide range of light values in a single exposure. There is a way around this limitation, however, using a technique called high dynamic range (HDR) photography.

HDR requires you to make a number of bracketed exposures in order to capture both the dark and bright areas with detail. You then emulate what the eye does by integrating those several exposures into one record of the scene by using computer software made specifically for this purpose.

Many cameras now have shutter speeds as fast as 1/2000 second, and that's the speed you should use—even faster if available. Set up the shot using Shutter Priority exposure mode so that the bracketing is produced as a result of different aperture settings, but raise the ISO if need be so that the aperture is narrow enough to render the entire scene sharp (long depth of field). Include one exposure where the brightest areas are fully exposed with no blinkies displayed in the highlight warning. Then make at least two exposures that insure the shadows will record with detail, which will probably overexpose the highlight areas considerably. You then use software to combine the bracketed images. There are numerous programs that will do this; be on the lookout for HDR capability as one of the feature sets.

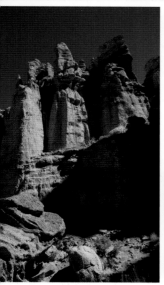 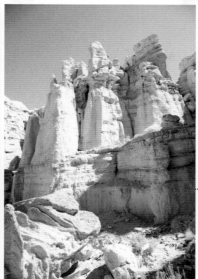 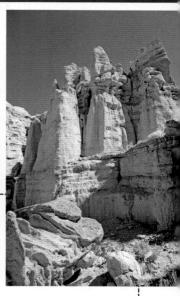

The photos above of a light-colored rock formation were made in bright sunlight at high altitude—a nearly impossible lighting situation to capture in one frame. Exposing for the highlights—keeping detail and texture in the bright areas, as in the left-hand photo—makes the shadows extremely deep, while exposing to show detail in the shadow areas (middle) burns out the highlights. To find a compromise, you can combine the two versions using software that produces a single image that will reveal texture in the highlights and detail in the shadows (right hand picture—I have not shown the middle frame of the bracket, just the two extremes and the HDR result.)

Exposure Mode: *Shutter Priority*
Aperture: *Bracketed: f/14 (left); f/5.6 (middle)*
Shutter Speed: *1/2000 second*
ISO: *400*
Metering: *Spot, read from brightest areas of rocks (left); read from shadow area (middle)*
White Balance: *Daylight*
Photoshop HDR software used to combine bracketed photos

A

Ambient light (see Available light)

Aperture 15, 16, 18, 20-21, 26, 31, 32, 42, 48, 90, 108

 see also f/stop

Aperture priority mode 20, 42, 63, 72, 86

Artificial light 42, 54, 55, 64

Autoexposure Bracketing (AEB) 42-43

Autoexposure lock (AEL) 48, 55, 76, 78, 89, 90, 92-95

Available light 24, 42, 54

B

Backlight 60, 69

Bias toward the highlight 88-90

Black-and-white photography 78

 see also Monochrome

Blinkies 34-36, 96, 108

 see also Highlight warning

Blur 17, 22, 23, 24, 28, 31

Bracketing

 AEB (see Autoexposure bracketing)

 HDR 108

 Tone curve 100, 102

C

Center-weighted averaging 52, 55, 69, 78-79, 85, 86, 88-91, 92, 97

Character (of light) 56-59

Cold light 59

Color saturation 36, 49, 58, 72, 93, 96

Color temperature (see White balance)

Computer processing (see Image processing)

Contrast 34, 40, 56, 68-69, 72, 80

 High contrast 69, 85, 88, 92, 96-97, 99, 108

 Low contrast 70-73

 see also Tone curve

D

Depth of field 20-21, 23, 27, 31, 33, 108

Depth-of-field preview 20

Digital noise 18, 19, 23, 44-46

Direction (of light) 60-61

Electronic noise (see Digital noise)

Equivalent exposure 26-31

Existing light (see Available light)

Exposure compensation 28, 34, 35, 42, 48, 49, 63, 93, 94, 96-99

Exposure lock (see Autoexposure lock)

Exposure value (EV) 16, 26, 28, 85, 94, 96

F

f/stop 20

 see also Aperture

Fill light (see Reflected fill)

Filters (in-camera) 78

 see also Neutral density filter

Flat light 70-73

Focal length 20, 32, 84

Handholding camera 16, 18, 19, 23, 29, 45, 47, 73, 77

Hard light 56

High dynamic range (HDR) 83, 108-109

High key 62

Highlight warning 34-37, 49

Highlights 34, 39, 49, 85, 86, 88, 96, 109

Histogram 38-41, 76

I

Image processing 39, 42, 70, 72, 73, 88, 104, 106

Image quality 18, 23, 34, 44, 46

Image stabilization 23, 44, 73

 see also Tripod